IMAGES
of America

ROSLINDALE

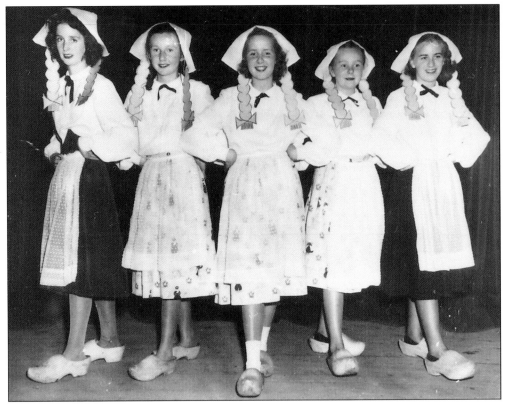

These young ladies clogged their way to fame at a parish variety show held at the Sacred Heart Church. Wearing fetching Dutch frocks, complete with dangling braids, they entertained their audience with song and the clomp of their clogs. (Courtesy of the Sacred Heart Church.)

IMAGES
of America

ROSLINDALE

Anthony Mitchell Sammarco

ARCADIA
PUBLISHING

Published by Arcadia Publishing
Charleston, South Carolina

Printed in the United States of America

Library of Congress Catalog Card Number: Applied For

For all general information contact Arcadia Publishing at:
Telephone 843-853-2070
Fax 843-853-0044
E-mail sales@arcadiapublishing.com
For customer service and orders:
Toll-Free 1-888-313-2665

Visit us on the Internet at www.arcadiapublishing.com

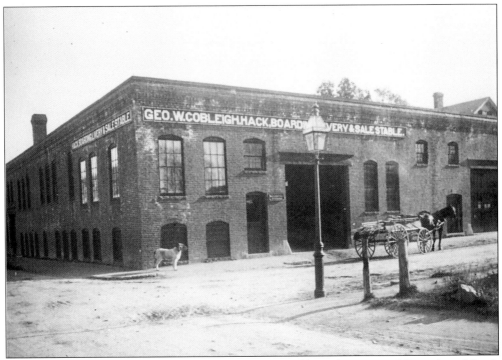

George W. Cobleigh had a hack, boarding, and livery stable at the corner of Corinth and Birch Streets. (Courtesy of the Roslindale Historical Society.)

Contents

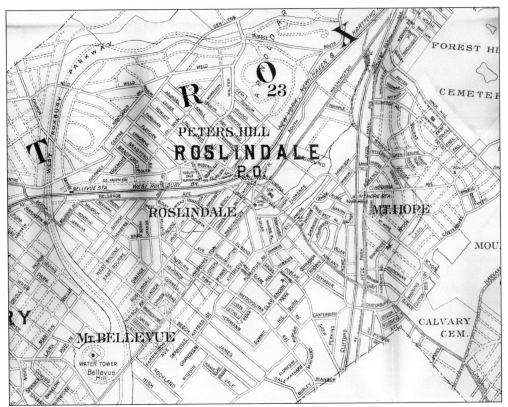

This 1909 map of Roslindale was published by the Boston Suburban Book Company for the *Roxbury Blue Book*. (Courtesy of Stephen D. Paine.)

Introduction

The following article by Richard W. Davis (proprietor of the Davis Monument Company) appeared in the first edition of the *Parkway Transcript*. The article reveals the interesting story of how Roslindale was named, thus setting the story straight at last. Once a part of Roxbury, the neighborhood of Roslindale was incorporated in the newly formed town of West Roxbury in 1851, together with the modern-day West Roxbury and Jamaica Plain. The town, including Roslindale, was annexed to the city of Boston in 1874.

"Roslindale seems to have been originally known as 'South Street Crossing,' the name being derived from the old Boston and Providence railroad that crossed South street where the railroad station now stands. About the year 1870 the postal authorities decided to establish a post-office in this new growing community and not knowing an appropriate name to call the branch asked the citizens of the section to bestow a name upon the community.

"A meeting of the citizens was called to decide upon a name for this section of Roxbury. At the meeting or assembly there were about ten citizens present who were the extensive land owners of the community, the more prominent ones being Messrs. Bradford, Dudley, Norton, Pierce and Skinner. Each of them spoke and suggested a name befitting the community.

"Finally, John Pierce, an Englishman by birth and a person who had travelled extensively, told the assembled citizens that the so-called 'South street crossing' and its vicinity reminded him a great deal of a certain historical town he had visited in Scotland. Mr. Pierce said that the rich and romantic landscape of this section of Boston composed so fine a variety of hill and dale, stately trees and profuse shrubbery recalled in his mind the beautiful little historic town of Roslin or sometimes spelled Rosslyn in Scotland, which is situated about seven miles southwest of Edinburgh in the parish of Lasswade.

'To the tourist,' Mr. Pierce said, 'whether a lover of antiquities, or an admirer of romantic scenery, few places present so much delightful variety, and excite so intense an interest as does Roslin, Scotland.' The beautiful river Esk, as it glides along its meandering track, reminded him of Charles river, which inspires with pure delight the admirers of nature. Roslin with its venerable ruins of the ancient castle, or the profusely rich and varied sculpture of its elegant chapel, together with the various caves and excavations of its surrounding countryside would excite wonder and admiration in the mind of every intelligent visitor. Sir Walter Scott [1771–1832] spent some of the happiest years of his early life at Roslin and it was in an humble cottage in Roslin where he was engaged in the revision of his collected writings until shortly before his death in December, 1832.

"Roslin Chapel, which was founded in 1446, by William St. Clair, third Earl of Orkney and Lord of Roslin, is one of the most highly-decorated specimens of Gothic architecture in Scotland and known throughout the world. 'At the Revolution of 1688,' continued Mr. Pierce, 'part of the chapel was defaced by a mob from Edinburgh, but was repaired in the following century by

General St. Clair. The chapel combines at the present time the solidity of the Norman with the minute decorators of the latest species of the Tudor age. It is impossible to designate the architecture of this building by any given or familiar term; for the variety and eccentricity of its parts are not to be defined by any words of common acceptation. The Nave is bold and lofty, enclosed as usual by side aisles, the pillars and arches of which display a profusion of ornament, particularly in the "Prentice's Pillar," with its finely-sculptured foliage. It is said that the master-builder of the chapel, being unable to execute the design of this pillar from the plans in his possession, proceeded to Rome to study a similar column there. During his absence his apprentice proceeded with the execution of the design, and upon the master's return he found this finely ornamented column completed. Stung with envy at this proof of the superior ability of his apprentice, he struck a blowe with his mallet and killed him on the spot.

'Beneath the chapel lie the Barons of Roslin, all of whom, till the time of James VII were buried in complete armour. This circumstance, as well as the superstitious belief that on the night before the death of any of the Lords of Roslin the chapel appears in flames, is the subject of Sir Walter Scott's fine ballad of Rosabelle.

'The ruins of Roslin Castle, with its triple tiers of vaults stand upon a peninsular rock overhanging the picturesque glen of the Esk. The origin of the castle is involved in obscurity, but it was long the abode of the family of St. Clair who were friends of Sir Walter Scott, Oliver Cromwell, and the ill-fated Mary, Queen of Scots. Indeed, Roslin Castle was the abode of Queen Mary for a considerable length of time, and Oliver Cromwell with his army encamped in Roslin at various times.

'Thus gentlemen,' concluded Mr. Pierce, 'I suggest that our community be known as Roslindale—Roslin after the historic and beautiful town I have just told you about, Roslin, Scotland, and the dale which I believe is very befitting to describe the beautiful hills and dales that nature has adorned our community with.'

"The assembled citizens then voted unanimously to name this particular section of Roxbury, Roslindale, and the memorable meeting was adjourned, having accomplished its purpose."

One

Early Roslindale

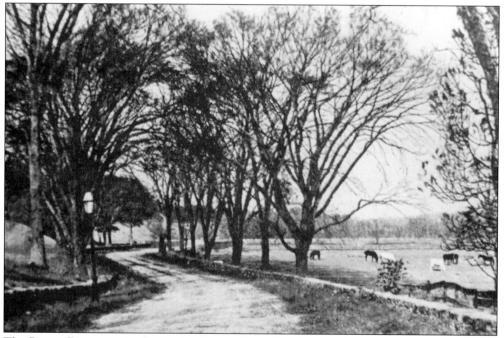

The Bussey Farm remained open land throughout the nineteenth century. Cows graze on the right and South Street meanders in the distance. Benjamin Bussey had purchased the Weld Farm in 1806, which extended from Center and South Streets to the west side of Church Street, and he lived on the estate as a gentleman farmer until his death in 1842. He bequeathed his estate to Harvard College and it is now part of the Arnold Arboretum.

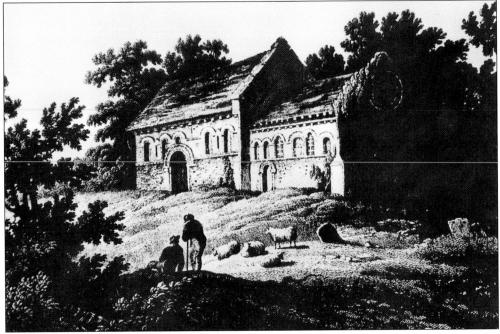

Roslindale, Massachusetts, was named for Roslyn, Scotland, and the dale (or valley) of the present town. The chapel of Roslyn Castle was sketched in the late eighteenth century, providing a historical link in the town's heritage. Roslindale was part of Roxbury until 1851 and was later included (together with Jamaica Plain) in the town of West Roxbury. (Courtesy of the Boston Public Library, hereinafter referred to as the BPL.)

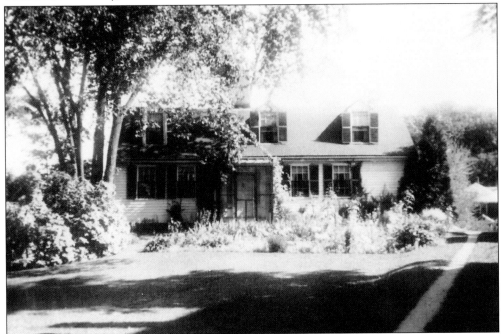

The Chamberlain House is the oldest house in Roslindale, and was built about 1725 and enlarged in 1775 on what is now Poplar Street. (Courtesy of David and Judith Kunze.)

South Street, which extends through the center of Roslindale, was lined with mature trees offering shade during the hot summer months.

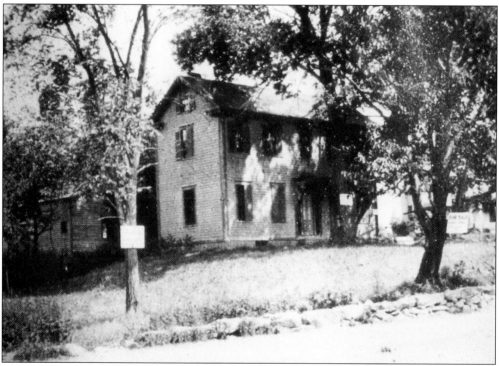

The Basto House was a late-eighteenth-century farmhouse in Roslindale. Located on Basto Terrace, off South Street, it was photographed while for sale at the turn of the century. (Courtesy of the Roslindale Historical Society.)

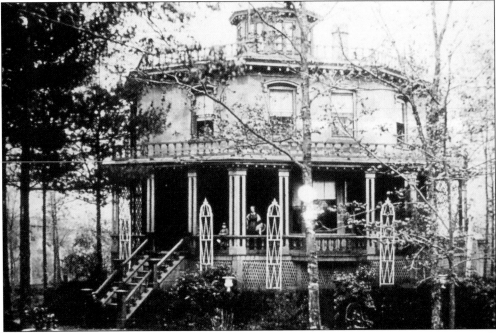

The Blakemore family built a fanciful octagon house, complete with a cupola, in the mid-1850s on Hyde Park Avenue. Blakemore Street perpetuates the family's name. (Courtesy of the Roslindale Historical Society.)

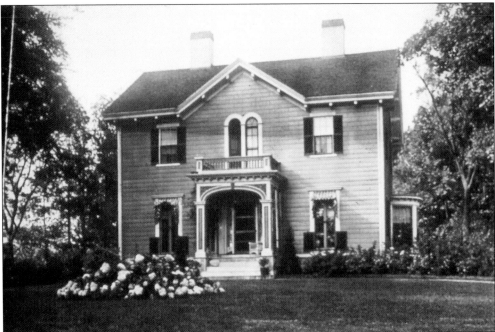

The Rooney House was an impressive Italianate house built at the time of the Civil War in Roslindale. Suburban housing came as a direct result of the Boston and Providence Railroad, which allowed commuters to build large houses outside of city limits and travel to Boston for business. (Courtesy of the Roslindale Historical Society.)

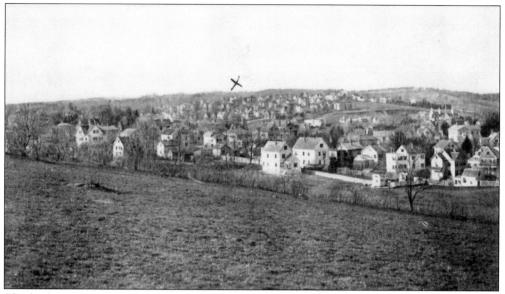

This bird's-eye view of Roslindale, looking northwest from Clarendon Hill (or Metropolitan Hill) at the turn of the century, gives a superb example of the landscape that attracted new residents in the late nineteenth century. Today, the view of Boston from the hill is breathtaking.

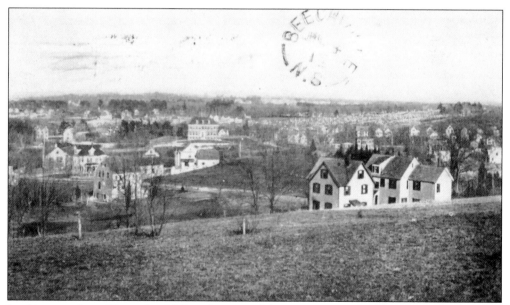

Looking east from Clarendon Hill at the turn of the century, new houses are visible on newly laid out streets. The Stephen Minot Weld School can be seen in the center of the photograph.

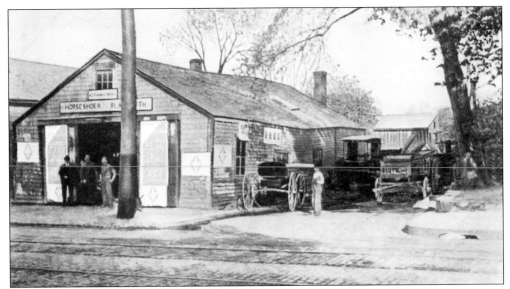

The Village Blacksmith Shop of Parker Weeks was a one-story wood building sheathed in clapboards. Many times the exterior was blanketed with billboards and posters advertising local town meetings or movies such as *The Earl and the Girl*. The shop also served as a smoke-filled headquarters of negotiation, and "many a deal was hashed out and cut and dried under the music of the old blacksmith's hammer."

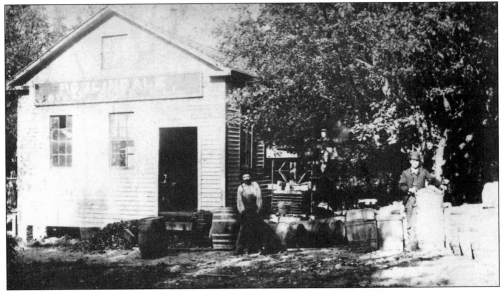

The Roslindale Cider Mill was located at the corner of Cummins Highway and Sycamore Street. Workers would press apples to extract the cider and bottle it for immediate use, allow it to age for applejack, or to sour for cider vinegar. (Courtesy of the BPL.)

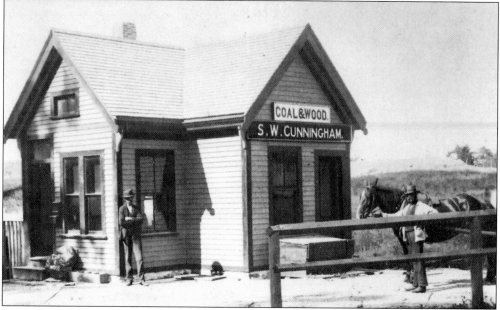

S.W. Cunningham Coal and Wood was in the Mount Hope section of Roslindale. Coal was used to heat houses with coal furnaces, which had to be "banked" (or raked) every evening to ensure continued heat. (Courtesy of the BPL.)

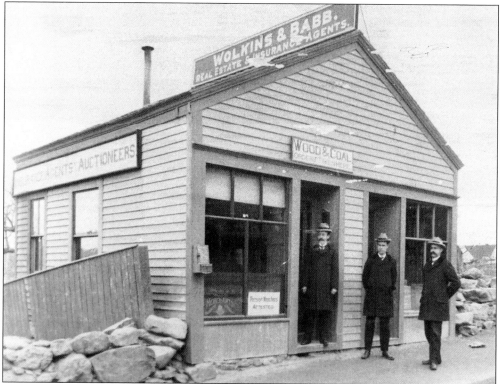

Wolkins and Babb was located at 806 South Street. The company dealt in real estate and insurance, conducted auctions, and provided wood and coal. (Courtesy of the BPL.)

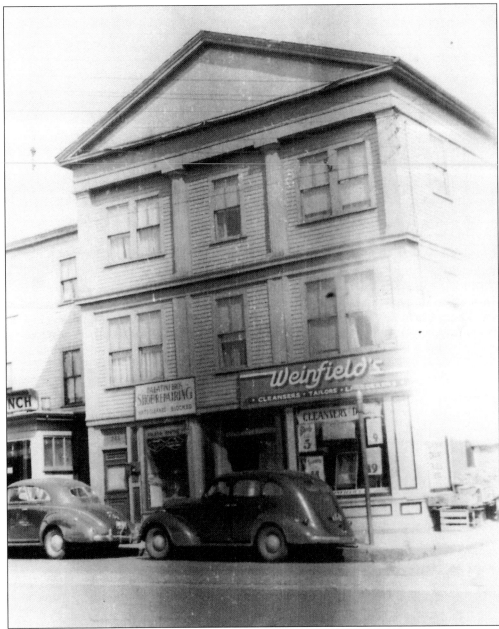

Association Hall was located on South Street opposite Poplar Street. The building was originally a one story wood framed school that was originally at the corner of Centre and Church Streets in West Roxbury. The former schoolhouse was moved to Roslindale Village after 1863 when it was greatly enlarged with storefronts and meeting space above. The original Greek revival school, the first in West Roxbury, was the top story with Doric pilasters supporting the pediment. By the turn of the century, Association Hall was used as the meeting place of the American Benefit Society, the Daughters of Rebecca, and the International Order of Odd Fellows. (Courtesy of the West Roxbury Historical Society.)

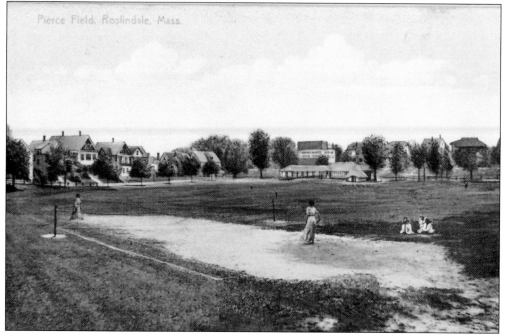

Pierce Field was named for John Pierce (often spelled Pearce), the man who suggested the name Roslindale for the former "South Street Crossing." Pierce's estate was on South Street and later became Fallon Field, a recreational center for the children of Roslindale.

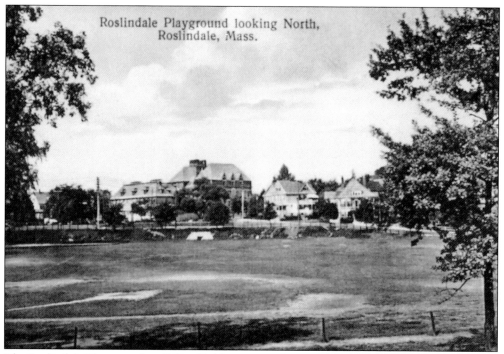

The Roslindale Playground, or Fallon Field as it is now known, was once the estate of John Pierce, a gentleman who "was most generous towards projects of community welfare" in Roslindale.

17

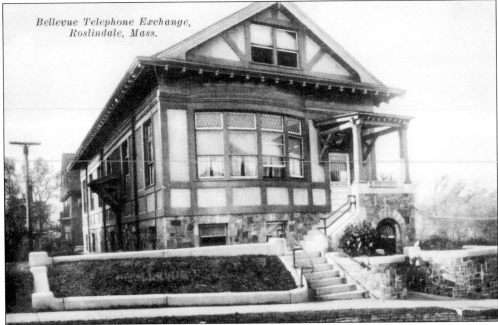

The Bellevue Telephone Exchange offered telephone service to residents of Roslindale and West Roxbury at the turn of the century. Alexander Graham Bell had invented the telephone in 1877, sending voice messages via wires.

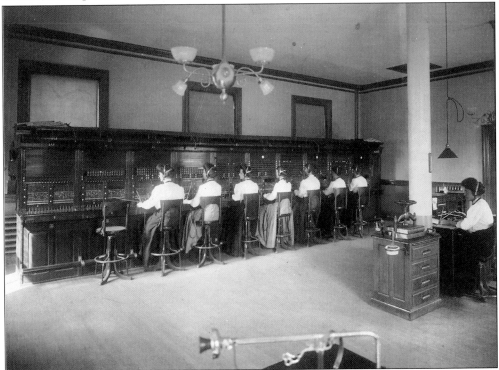

Telephone operators would monitor a fifty-wire switchboard to connect callers. A supervisor sits at her desk on the right awaiting route calls and to ensure smooth and efficient service.

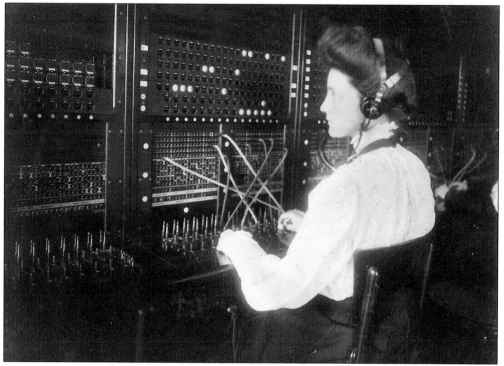

The switchboard had numerous lines that the operator would connect. Do you remember the days of party lines and crank-handled telephones?

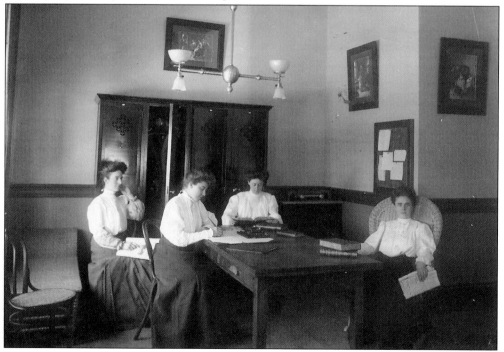

The lounge at the Bellevue Telephone Exchange offered operators a pleasant room to relax in, away from the constant ringing of telephone lines that required prompt connection.

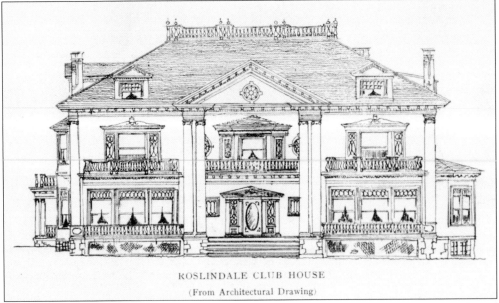

ROSLINDALE CLUB HOUSE
(From Architectural Drawing)

The Roslindale Club was founded in 1891 by eleven young men at the corner of South and Conway Streets. From this beginning was formed the Roslindale Cycle Club, a leading racing and cycling club. (Courtesy of the BPL.)

Lewis S. Breed, DDS, served as representative from Roslindale in 1901. The respected dentist "was largely instrumental in procuring the passage by the House of a bill for five-cent fares within the city limits." (Courtesy of the BPL.)

Two

Scenic Roslindale

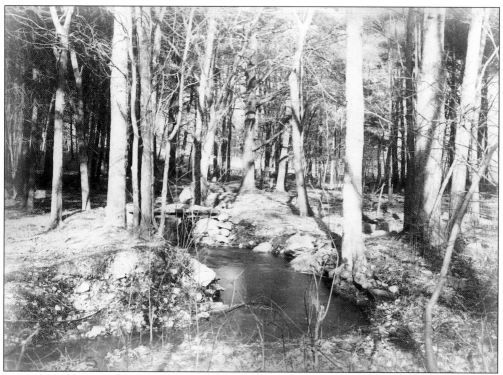

Grew's Woods was the estate of Henry Sturgis Grew. The estate encompassed hundreds of acres in both Roslindale and Hyde Park, and was developed as an attraction for visitors. The natural beauty of the area was preserved with brooks passing through the stand of trees. Today, much of the land has been preserved as the Stony Brook Reservation, and a portion of the estate is now the George Wright Golf Course. (Courtesy of the Hyde Park Historical Society.)

Henry Sturgis Grew (1808–1891) was a partner of James Read, for whom Readville was named. Grew was later a founder of the Meredith & Grew real estate development company that was continued by his sons Henry and Edward. Henry Sturgis Grew visited Hyde Park in 1845 and found the countryside so inviting that he purchased an 800-acre estate and embellished it, encouraging visitors to stroll through the grounds.

Grew's Woods gave the impression of being far in the country, but it was only 6 miles from Beacon Hill. A footbridge crosses a brook in this photograph of 1890. (Courtesy of the Hyde Park Historical Society.)

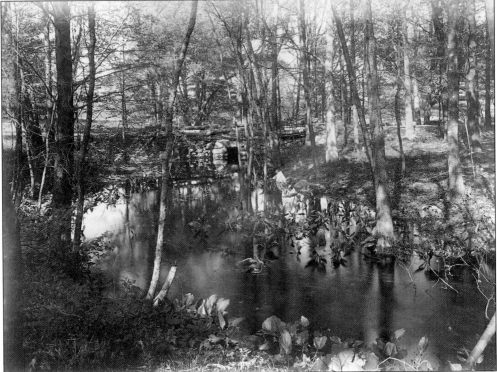

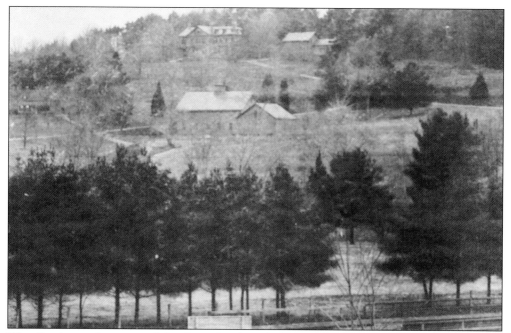

Woodlands was the estate of the Grew family and was an 800-acre tract of land that extended from Austin Street in Hyde Park to Roslindale. Formerly the Noah Withington farm, the area was often called "Monterey" and had a caretaker's house on De Forest Street. The gates to the estate were on West Street. (Courtesy of the Hyde Park Historical Society.)

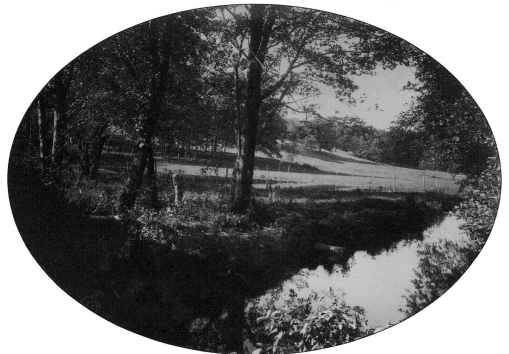

Stony Brook flowed placidly past a gently sloping lawn on the Grew Estate. (Courtesy of the Hyde Park Historical Society.)

A young girl stands on Poplar Street looking toward Roslindale in Grew's Woods in 1910. (Courtesy of Claude Mac Gray.)

A rustic bridge made of birch logs spans a creek in the Stony Brook Reservation at the turn of the century. (Courtesy of the BPL.)

John J. Enneking was not just an important impressionistic artist, but an early advocate for the preservation of the natural beauty of Hyde Park and Roslindale. He served as park commissioner for the Town of Hyde Park and was instrumental in the creation of the Stony Brook Reservation. Enneking Parkway perpetuates his name and connects West Roxbury, Roslindale, and Hyde Park through the Stony Brook area.

A light covering of snow blankets Grew's Woods in the 1890s. (Courtesy of the Hyde Park Historical Society.)

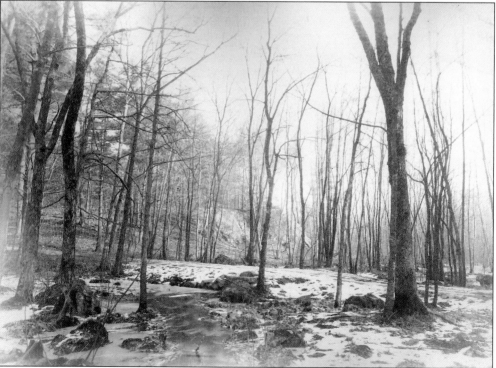

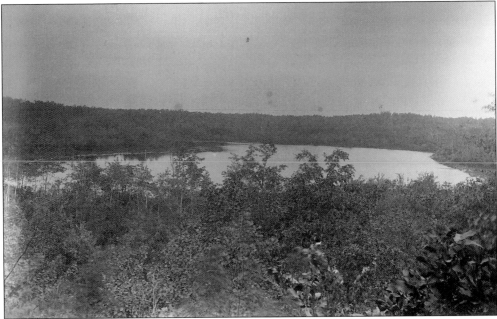

Muddy Pond, or Turtle Pond as it is now known, is an oval-shaped pond in the center of the Stony Brook Reservation. (Courtesy of the Hyde Park Historical Society.)

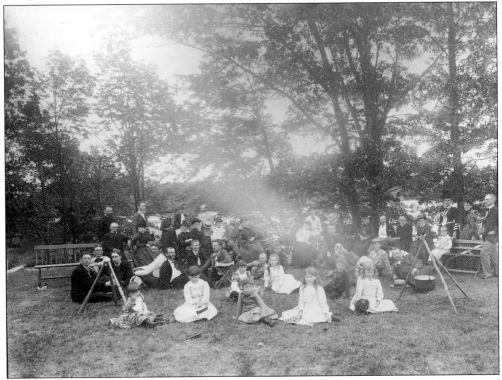

Picnickers pose for a photograph at the turn of the century with Muddy Pond just beyond the trees. These people would "commune" with nature while enjoying the scenic beauty, and a copious lunch.

The Hermit of Grew's Woods was an Englishman by the name of John Gatley. Born to a wealthy English family, he emigrated to the United States in 1847, laying claim by squatter's rights to a small section of the Grew Estate deep in the woods. He was supported by the generosity of Henry Grew, but would trap and mount many wild animals which he sold to support his meager existence. (Courtesy of the Hyde Park Historical Society.)

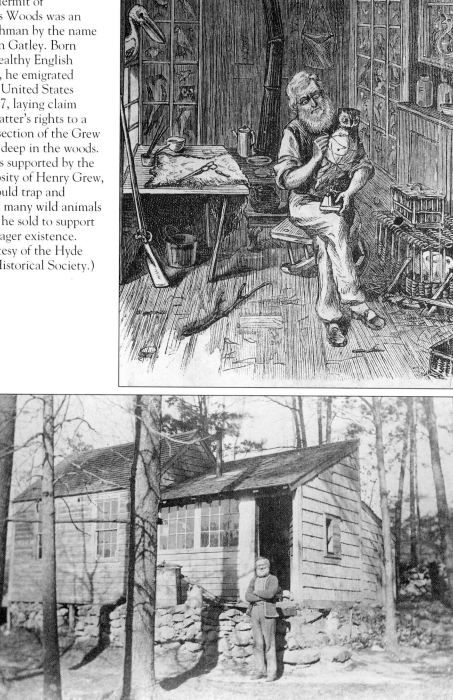

The shack of the Hermit of Grew's Woods was originally a one-room structure built of wood planks, but an ell was added for a taxidermy studio. In this studio, Gatley mounted the birds, rabbits, snakes, frogs, and fish that he offered for sale after a long winter. (Courtesy of the Hyde Park Historical Society.)

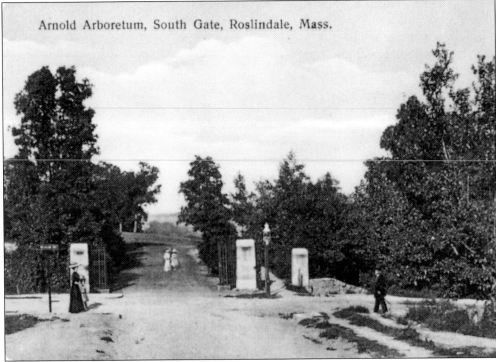

Arnold Arboretum, South Gate, Roslindale, Mass.

The South Gate to the Arnold Arboretum was just off South Street. The arboretum, which was originally the Benjamin Bussey Estate, was established in 1872 and lies partly in Jamaica Plain and Roslindale.

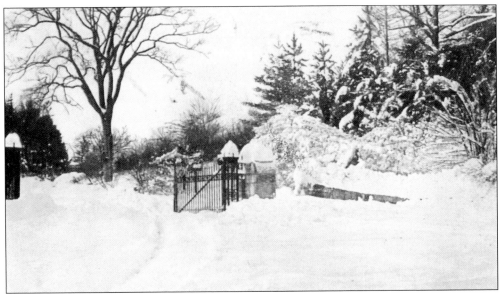

Snow-capped piers flank the entrance to the South Street Gate of the Arnold Arboretum in 1912. Though the arboretum is glorious in the other three seasons, winter creates a pristine beauty when snow and ice cover all.

The entrance to the Mount Hope Cemetery has an office on the left, and a chapel built out of stone quarried on the property. Laid out as an arboretum cemetery in 1852, it was advertised as being "approachable by free and spacious roads . . . affording delightful drives through rural districts of the country," and only 5 miles from Boston. Today, Mount Hope is maintained by the City of Boston.

The exercises at the consecration of Mount Hope Cemetery were held on June 24, 1852. The cemetery grounds were open to the public. David Haggerston, superintendent, lived on the property and would render assistance and advise in the selection of eligible sites for family burial-places.

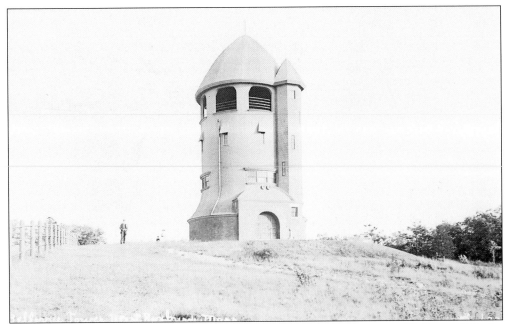

The Bellevue Tower was a water tower built of wood shingles at the crest of Bellevue Hill, the highest elevation in the city of Boston. The hill is encircled by West Boundry, Cedar Crest, and Blue View Roads, Blue View Circle, and Cedar Crest Lane.

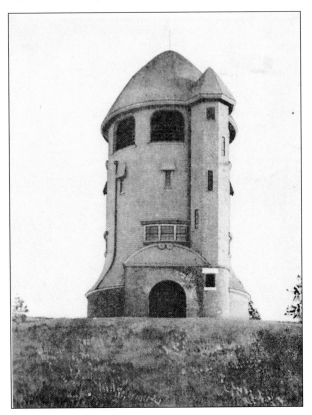

The wood-shingled Romanesque Revival water tower had a shaft in the center that would store water for periods of drought and an enclosed staircase on the right that led to an observatory which afforded unsurpassed views of Boston and the countryside.

Three

Roslindale Village

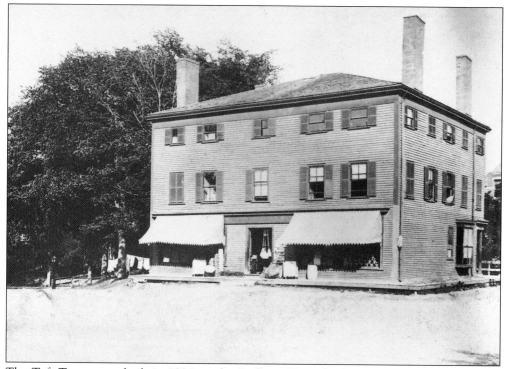

The Taft Tavern was built in 1804 on the Dedham Turnpike (now Washington Street) and was a popular place to stop for a hot meal or to stay overnight on a trip south. The three-story Federal tavern was also known as the Union Hotel and was a "social and civic meeting place" in the nineteenth century. It later housed a provision store on the first floor and apartments above. (Courtesy of the BPL.)

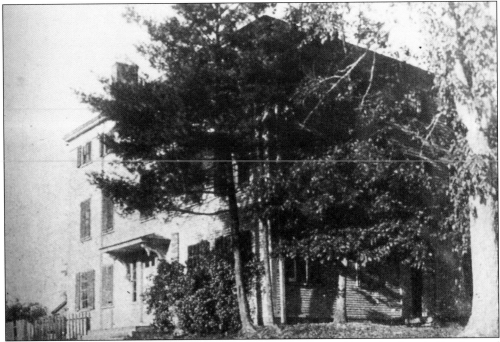

By the turn of the century, the Taft Tavern was no longer an inn dispensing hospitality. It stood as an eyesore in Roslindale Village and was demolished to make way for a new library in 1904. (Courtesy of the Roslindale Historical Society.)

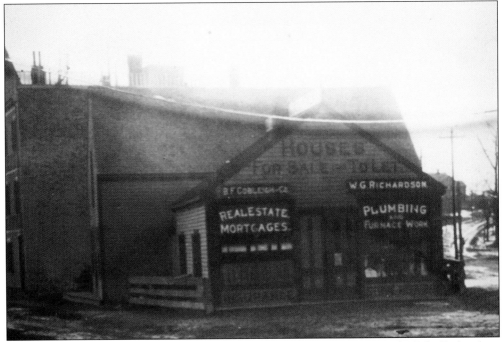

B.F. Cobleigh & Company, which dealt in real estate and mortgages, and W.G. Richardson Company, a plumbing and furnace shop, shared this building at the turn of the century. (Courtesy of the Roslindale Historical Society.)

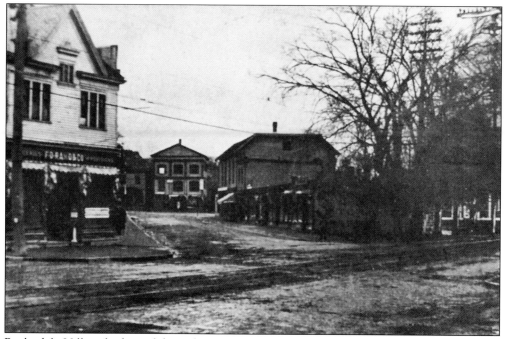

Roslindale Village had wood-framed stores on Washington and Corinth Streets at the turn of the century. (Courtesy of the BPL.)

Fred D. Rand had a grocery store at the corner of Poplar and Corinth Streets in the early twentieth century. Rand's was known as the "S.S. Pierce" of Roslindale, and he delivered groceries by horse-drawn delivery wagons. The company slogan was "Prudent families buy at Rand's." (Courtesy of the BPL.)

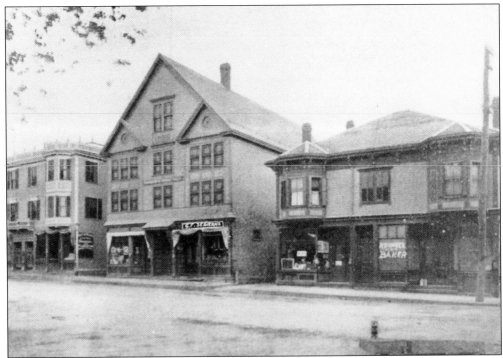

Washington Street in Roslindale Village had C.F. Seaverns' store on the left and R. Dunkel's Bakery and Ice Cream Parlor on the right. (Courtesy of the BPL.)

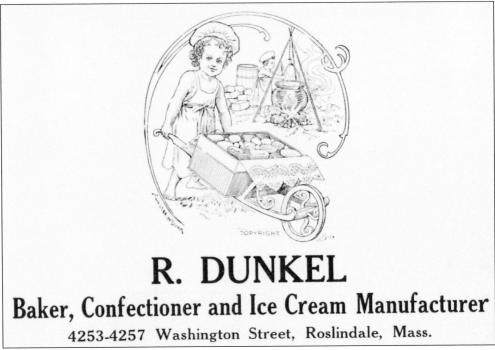

R. DUNKEL

Baker, Confectioner and Ice Cream Manufacturer

4253-4257 Washington Street, Roslindale, Mass.

Dunkel's was a noted baker, confectioner, and ice cream manufacturer established in 1885. (Courtesy of Stephen D. Paine.)

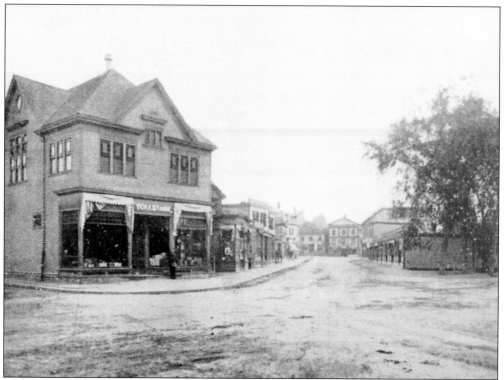

Poplar Street, seen from Washington Street, had W.H. Stone's store on the left. (Courtesy of the BPL.)

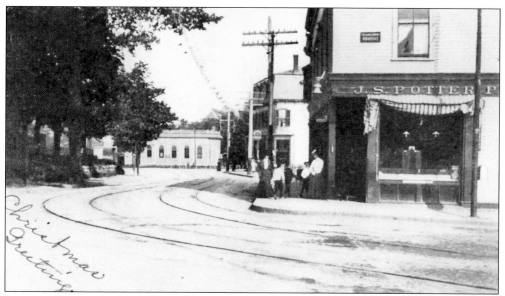

South Street curved at Potter's Corner. J.S. Potter's Pharmacy was on the right and the Roslindale library can be seen just past the trees.

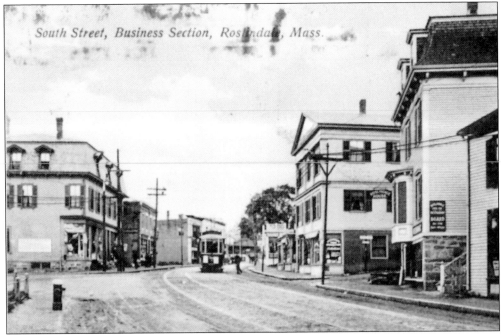

South Street was the business district of Roslindale at the turn of the century. A streetcar approaches from Roslindale Village. (Courtesy of Claude Mac Gray.)

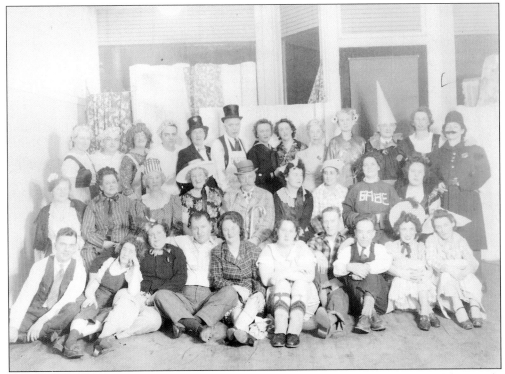

Employees of Park Snow celebrated the New Year in 1950 in costume! (Courtesy of the BPL.)

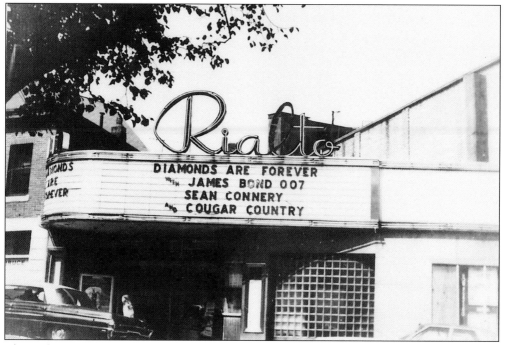

The Rialto was the village cinema and was located in this nifty theater. The James Bond movie *Diamonds Are Forever* was playing when this photograph was taken in 1972. (Courtesy of the Sacred Heart Church.)

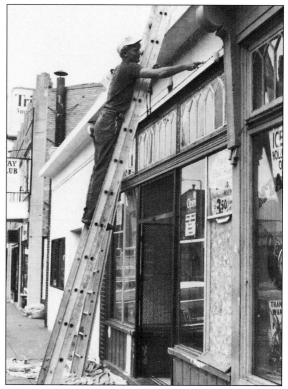

A workman paints the mullions of one of the unique storefronts along Washington Street in Roslindale Village. (Courtesy of the BPL.)

Irving W. Adams (1893–1918) was the first man from Massachusetts killed in action during World War I. Son of Louis and Florence May Adams of South Street, Irving attended the Longfellow School and later worked as a leather salesman. He enlisted in the army on May 22, 1917, and was killed at Rambucourt, France, on February 9, 1918. (Courtesy of the Roslindale Branch of the Boston Public Library.)

A mother talks to her baby in Adams Park in Roslindale Village. The American Legion, Irving W. Adams Post 36 of Roslindale, was instrumental in persuading the City of Boston to name the park in memory of Adams. (Courtesy of the BPL.)

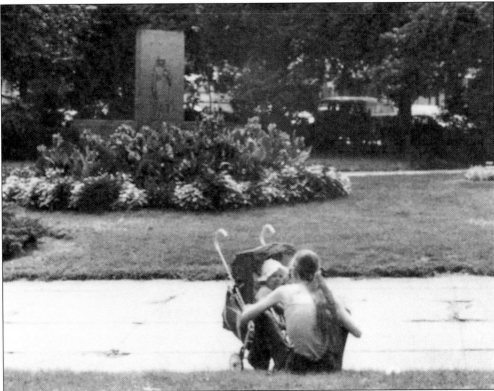

The World War I Memorial in Adams Park was sculpted by Albert Henry Atkins (1899–1951) in 1922 in memory of the men and women of Roslindale who died in the service of their country during World War I.

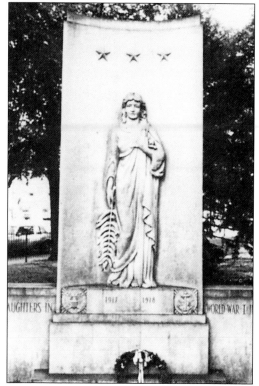

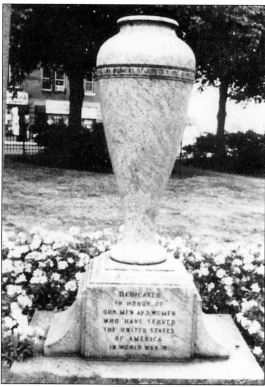

The Gold Star Mothers' World War II Memorial in Adams Square was erected in 1945 in honor of the men and women who served in the United States Armed Forces in World War II.

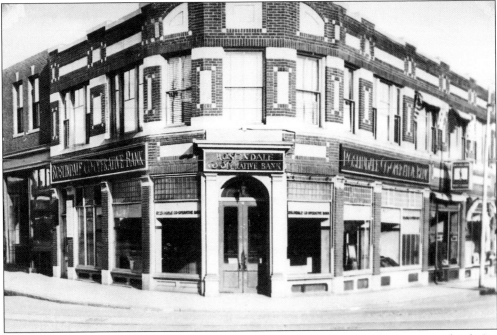

The Roslindale Co-Operative Bank was located at 806 South Street in this attractive brick Art Deco building. (Courtesy of the BPL.)

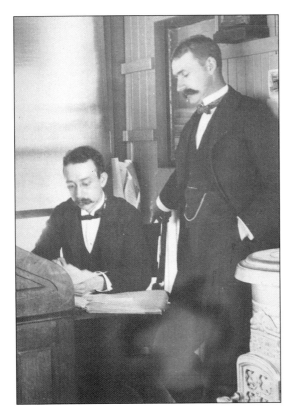

Two clerks review ledgers in 1898 at the Roslindale Co-Operative Bank. (Courtesy of the BPL.)

The Roslindale branch of the Suffolk Savings Bank for Seamen and Others was opened at 754 South Street.

The lobby of the Suffolk Savings Bank had an attractive Colonial Revival design with an impressive checkerboard floor of white and black marble.

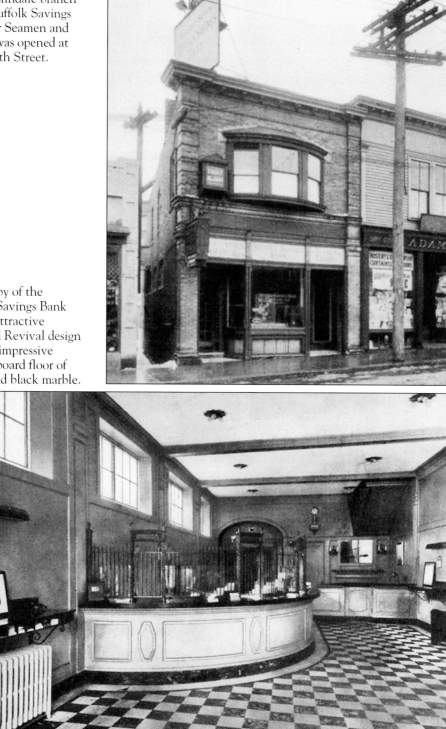

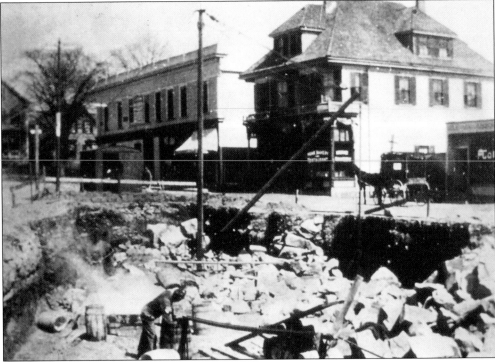

Workmen prepare the foundation for Cobleigh's Block, later the Central Building, that was built in 1899 at the junction of Birch, Belgrade, and South Streets. (Courtesy of the Roslindale Historical Society.)

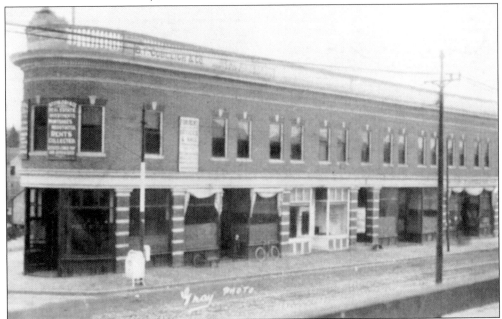

B.F. Cobleigh built this office building to house many different businesses near Roslindale Village. Cobleigh was a real estate developer who also acted as an auctioneer of land and offered mortgages on property. (Courtesy of the BPL.)

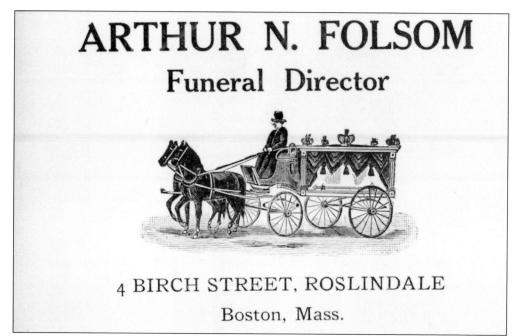

ARTHUR N. FOLSOM
Funeral Director

4 BIRCH STREET, ROSLINDALE
Boston, Mass.

Arthur N. Folson was a funeral director whose parlor was at 4 Birch Street in Roslindale. At the turn of the century, wakes were often held at the deceased's home rather than in a funeral parlor. (Courtesy of Stephen D. Paine.)

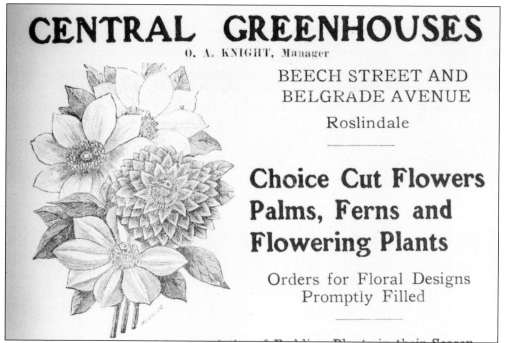

CENTRAL GREENHOUSES
O. A. KNIGHT, Manager

BEECH STREET AND
BELGRADE AVENUE
Roslindale

Choice Cut Flowers
Palms, Ferns and
Flowering Plants

Orders for Floral Designs
Promptly Filled

The Central Greenhouses were at the junction of Beech Street and Belgrade Avenue. Not only were cut flowers available but "all the latest and best varieties of bedding plants in their season" could be obtained here from O.A. Knight. (Courtesy of Stephen D. Paine.)

The Roslindale Woman's Club was founded in 1911 and the first president was Mrs. George A. Tyzzer. According to the bylaws, "the object of this Club [was] to promote any and all interests pertaining to the general welfare of the community." (Courtesy of the BPL.)

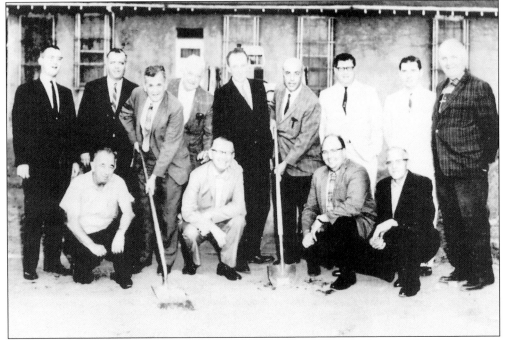

The John J. Williams Council #1308 of the Knights of Columbus breaks ground for a new home in 1967. (Courtesy of the Sacred Heart Church.)

N R A COMMITTEE of ROSLINDALE

To the Organization Leaders of Roslindale:

The N R A Committee of Roslindale appeals to you to attend the MEETING at the ROSLINDALE MUNICIPAL BUILDING, WEDNESDAY, AUGUST 30 at 8 o'clock and to have as many of your members as possible present and ready to serve as volunteers going from house to house to sign up every householder in Roslindale on Consumer Cards and to have them display the Blue Eagle. Men and women both are welcome to join and do their part. It is a tremendous job but will be very easy if sufficient patriotic-minded citizens volunteer. Each will be assigned to a particular street and the work will be made as simple as possible.

The success of N R A will be a distinct benefit to your organization as it will mean far less funds for welfare work as people return to work and the paid-up membership list will get back to normal. On this assumption it will well pay your organization to get together a number of volunteers who will help in this canvas.

Your members are asked to give - not money - but of time - To give not until it hurts, but until it helps - helps our fellow-men, our country and ourselves. We need the courage of 1917 and 1918 in 1933 - courage founded upon faith sublime.

National Recovery means the restoration of prosperity - American pride and self respect; you are asked to join with your fellow citizens in the mightiest movement in the history of the world. The President's emergency reemployment campaign requires your support through cooperation with your local N R A Committee. By that support and cooperation you will hasten the day when millions of unemployed will once more be at work, the wheels of industry once more will be turning, and the people of America once more living in security and contentment.

Yours till the back of the depression is broken,

N R A Committee of Roslindale

Fred C. Hailor, Major Thomas B. Fitzpatrick, Major

The Roslindale Committee of the National Recovery Act was co-chaired by Majors Fred Hailer and Thomas Fitzpatrick. (Courtesy of the BPL.)

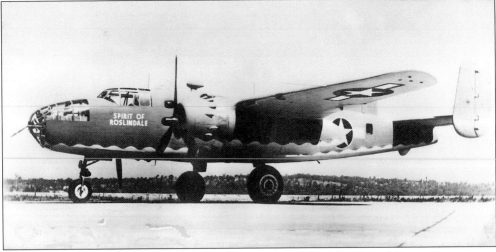

The *Spirit of Roslindale* was a B-25 bomber that was donated to the United States Government during World War II by the people of Roslindale, Massachusetts. The Roslindale Board of Trade was successful in raising $250,000 to purchase the plane through a war bond drive. The whereabouts of the plane is unknown at the present time, but it shows the generosity of the people of Roslindale during the war effort. (Courtesy of the Roslindale Historical Society.)

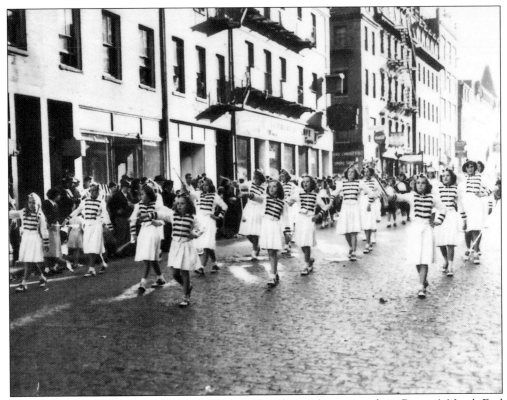

Members of the drill team of the Sacred Heart Church march in a parade in Boston's North End in the early 1960s. (Courtesy of the Sacred Heart Church.)

Four

Churches

The Second Church of Roxbury was gathered in 1712 on what is now Walter Street, near Mendum Street, at Peter's Hill. Joseph Weld donated the land for the meetinghouse and the cemetery, and the first minister was Reverend Ebenezer Thayer. A larger meetinghouse was built in 1773 at the corner of Church and Center Streets opposite South Street. Photographed in 1875, it was a typical New England meetinghouse located in the country on a tree-lined street. (Courtesy of the Roslindale Historical Society.)

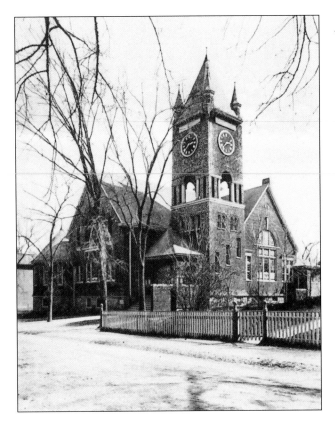

James Murray designed the Roslindale Congregational Church, which was built in 1896 on Ashland Street (renamed Cummins Highway in 1922), on land that was purchased from the Havey family. On August 2, 1893, Reverend Grover struck the first blow with a pick and threw the first shovelful of earth. The Shingle Style church is still an impressive building in Roslindale Village and the clock in the tower, which was the gift of the City of Boston, can be seen from much of Roslindale.

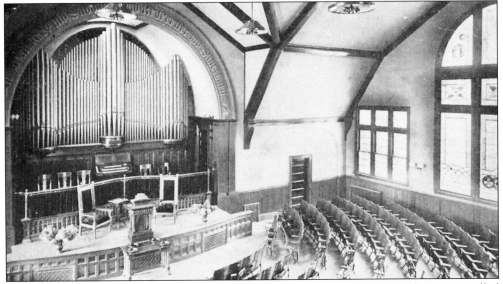

The interior of the Roslindale Congregational Church had an Estey Pipe Organ that was installed in 1906 and curved pews of golden oak which replaced wooden folding chairs in 1915. Above the chancel arch was stenciled "Ye Shall Keep My Sabbaths and Reverence My Sanctuary."

Reverend Richard Baxter Grover was minister of the Roslindale Congregational Church from 1890 to 1899. (Courtesy of the Roslindale Congregational Church.)

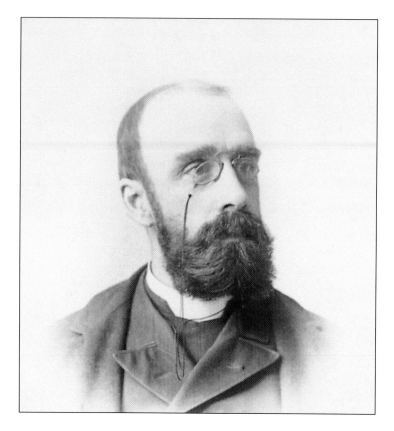

YOU are cordially invited to attend the informal reception to be held on Wednesday evening, October 28th, 1896, from 7 to 10 o'clock, in connection with the opening of the new Roslindale Congregational Church. Ushers will be in attendance to conduct you through the various departments. An interesting program will also be provided.

RICHARD B. GROVER,

Pastor.

The opening reception of the Roslindale Congregational Church was on October 28, 1896. The bell in the tower was donated by John Pierce, the man who suggested the name of Roslindale. (Courtesy of the Roslindale Congregational Church.)

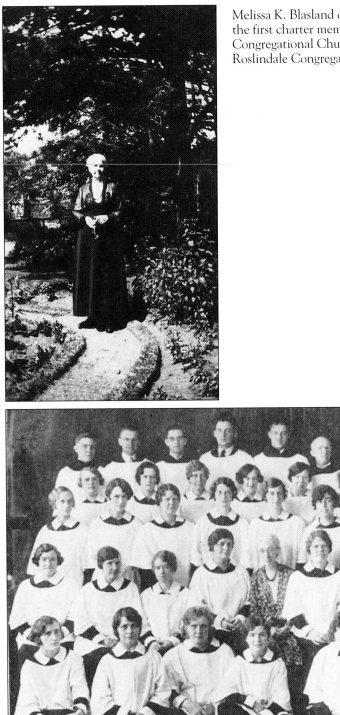

Melissa K. Blasland of 15 Tappan Street was the first charter member of the Roslindale Congregational Church. (Courtesy of the Roslindale Congregational Church.)

The choir of the Roslindale Congregational Church was organized in 1890. The director in 1930, Blanche Greenaway Allen, can be seen in the center of the second row. (Courtesy of the Roslindale Congregational Church.)

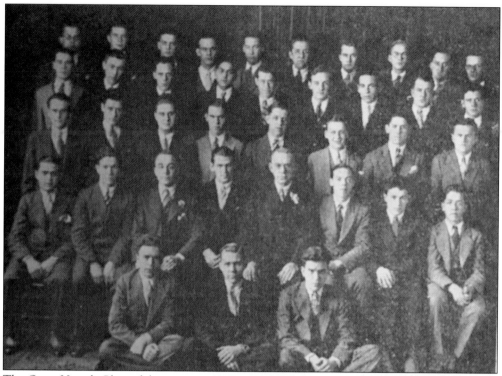

The Open Hearth Class of the Roslindale Congregational Church posed for their 40th anniversary portrait in 1930. (Courtesy of the Roslindale Congregational Church.)

To celebrate the 47th anniversary of the founding of the Roslindale Congregational Church, and the recent completion of major church renovations, a massive cake, a cross, and diamonds of candles were displayed on the pulpit on December 2, 1936. (Courtesy of the Roslindale Congregational Church.)

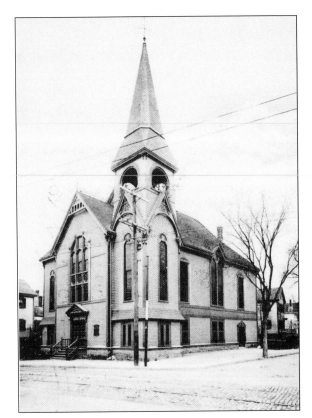

The Roslindale Baptist Church was built in 1889 at the corner of Asland (now Cummins Highway) and Florence Streets in a unique combination of the Stick and Shingle Styles of architecture.

Reverend Richard B. Esten was minister of the Roslindale Baptist Church at the turn of the century. It was said of him that he "not only serves his church well . . . but he has a magnetism and broad ideas which make his influence felt." (Courtesy of the BPL.)

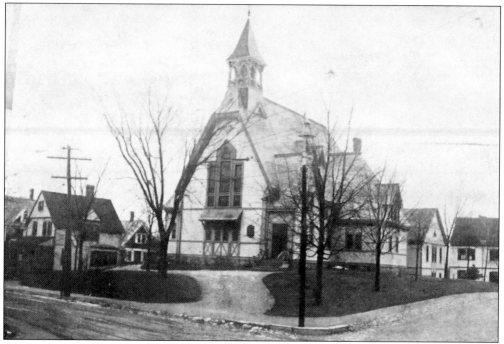

The Bethany Methodist Church was built in 1874 at the corner of Ashland (now Cummins Highway) and Sheldon Streets. It was a Methodist Episcopal church that burned during World War II. (Courtesy of Claude Mac Gray.)

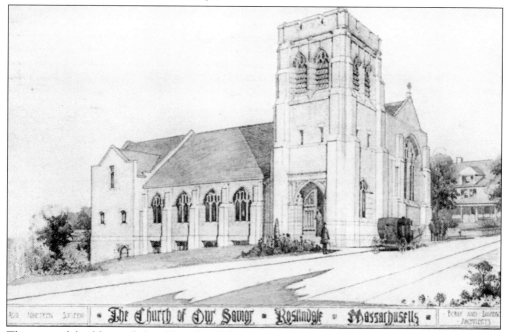

The second building of the Church of Our Savior, an Episcopal church, was designed by Berry and Davidson and built in 1916. The congregation later disbanded and the church was adapted as the Boston School of Modern Languages, which was founded in 1925. (Courtesy of Claude Mac Gray.)

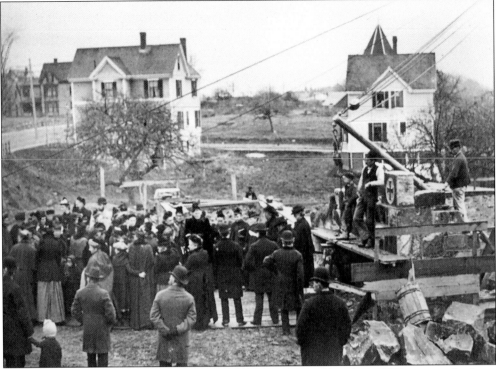

The laying of the cornerstone of the Roslindale Unitarian Church in 1891 attracted a large number of the congregation, who are seen watching as the granite cornerstone is laid on the right. (Courtesy of the Roslindale Historical Society.)

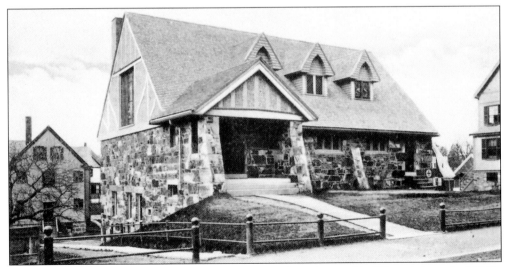

The Roslindale Unitarian Church was built in 1892 and was designed by Edwin J. Lewis Jr. (1859–1937), a noted architect who designed over forty Unitarian churches in this country and Canada.

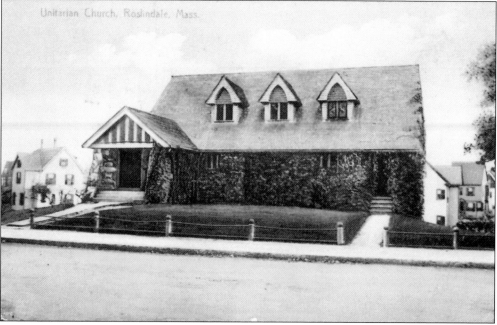

The Roslindale Congregational Church later disbanded; the building now houses Saint Anna's Orthodox Church. (Courtesy of Claude Mac Gray.)

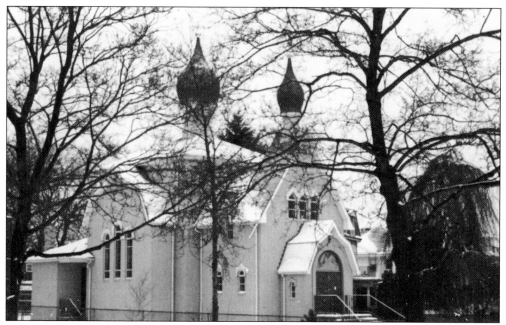

The Russian Orthodox Church of the Epiphany is at 961 South Street. The onion-shaped domes lend a distinctly Russian feeling to this church. (Courtesy of the BPL.)

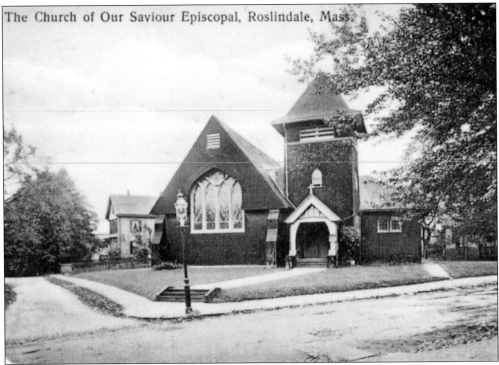

The Church of Our Saviour was founded as a mission in 1885 and the first rector was the Reverend Archibald Codman. The parish was established in 1889 and a Shingle Style church was built at the corner of Albano Street and Atherton Avenue.

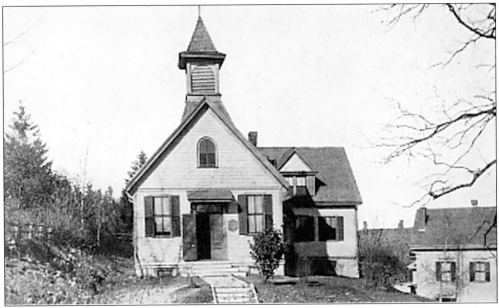

The German Lutheran church was a small wood-framed church that was built in 1887 on Cliftondsale Street and whose pastor at the turn of the century was Reverend J. Frederic Wenchel. Known also as the Bethlehem Evangelical Lutheron Church, the congregation worshiped in a small vernacular church in the German language.

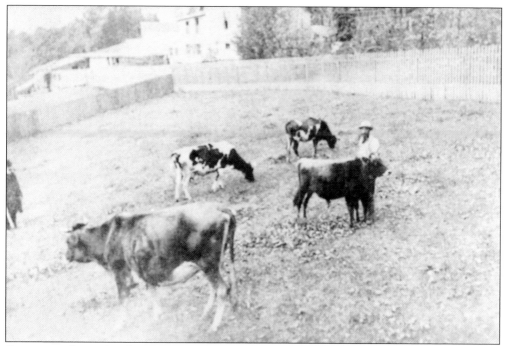

Cows grazed in the late nineteenth century on the future site of the Sacred Heart Church, at the present corner of Cummins Highway and Brown Avenue. (Courtesy of the Sacred Heart Church.)

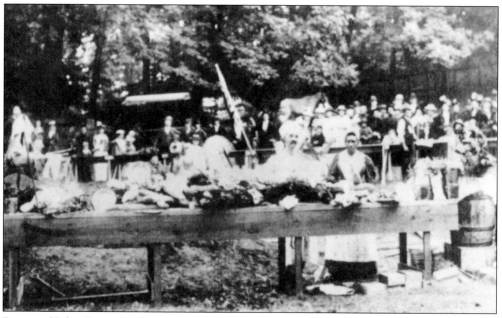

Reverend John Cummins, first pastor of the Sacred Heart Church, instituted an annual barbecue to raise the funds to erect a Catholic church in Roslindale. The first barbecue was held on September 1, 1884, and chef Charles W. Allen, in the chef's hat, came from Lexington, Virginia, to roast a great ox for the hungry parishioners. (Courtesy of the Sacred Heart Church.)

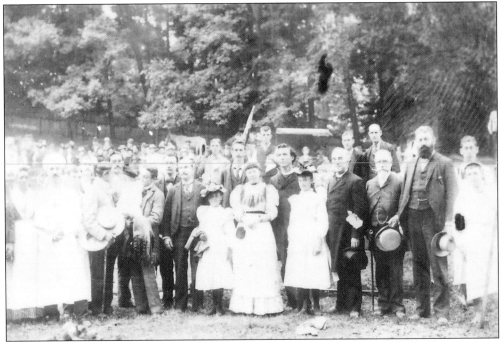

Chef Allen (second from the left), Reverend Cummins (fourth from the right), and parishioners of the proposed Sacred Heart Church pose for a group photograph during the first barbecue in 1884. (Courtesy of the Sacred Heart Church.)

A large tent was erected on the site of the future church for the first mass said in Roslindale on July 7, 1893. (Courtesy of the Sacred Heart Church.)

The Sacred Heart Church was built in 1893 of yellow brick at the crest of the hill at the corner of Cummins Highway and Brown Avenue. (Courtesy of the BPL.)

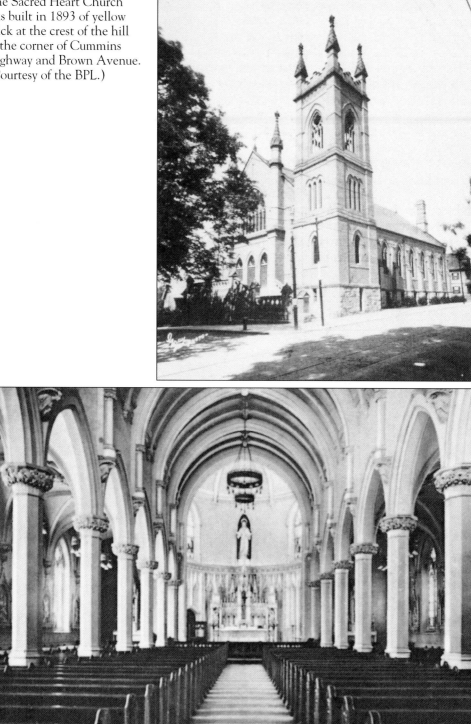

The nave of the church is an impressive space with columns supporting arches that lead to a magnificent altar.

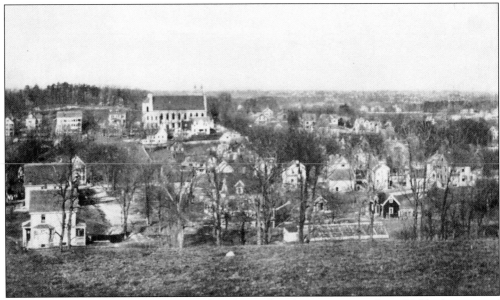

Looking northeast from Clarendon Hill (often referred to as Metropolitan Hill), this view of the Sacred Heart Church shows the neighborhood prior to 1909.

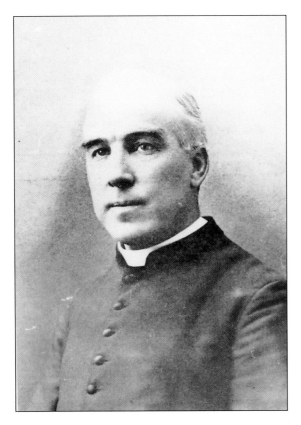

Reverend John F. Cummins was the first pastor of the Sacred Heart Church. (Courtesy of the Sacred Heart Church.)

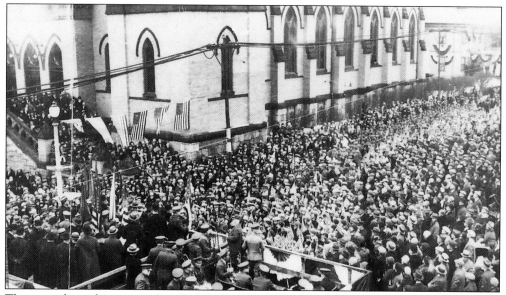

Throngs of parishioners and well-wishers attended the dedication ceremonies and created a virtual sea of people sharing in the excitement of Reverend Cummins. (Courtesy of the Sacred Heart Church.)

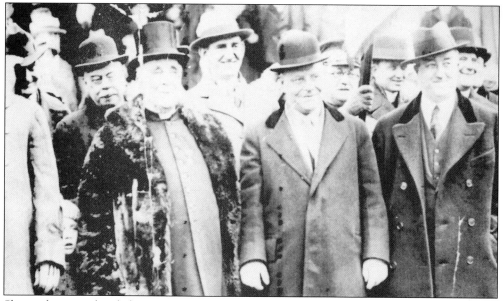

Shown here at the dedication of Cummins Highway (formerly known as Ashland Street) on March 1, 1929, are, from left to right, Reverend John F. Cummins, Mayor of Boston Malcolm E. Nichols, and District Attorney Foley. (Courtesy of the Sacred Heart Church.)

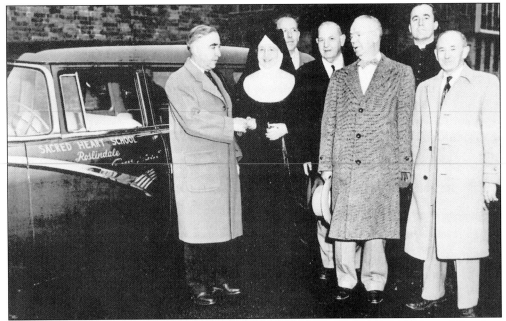

The "800 Club" presented a station wagon to the sisters of the Sacred Heart School in 1956. From left to right are Eugene Holmes, Sister M. Clarice, C.S.J., George O'Connell, T. Frank Blair, Paul Dallas, Monsignor Murray, and Mike Cunningham. (Courtesy of the Sacred Heart Church.)

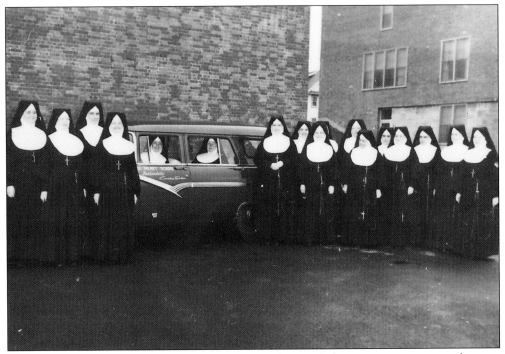

The sisters of the Sacred Heart School pose in and around the new station wagon that was presented to the school by the "800 Club." (Courtesy of the Sacred Heart Church.)

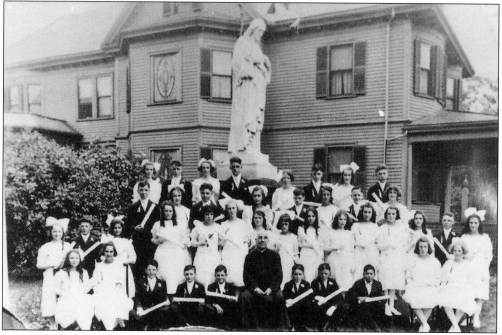

Members of the first graduation class from Saint Francis Xavier School pose in front of the rectory in 1922. Saint Francis Xavier School was the first parish school. (Courtesy of the Sacred Heart Church.)

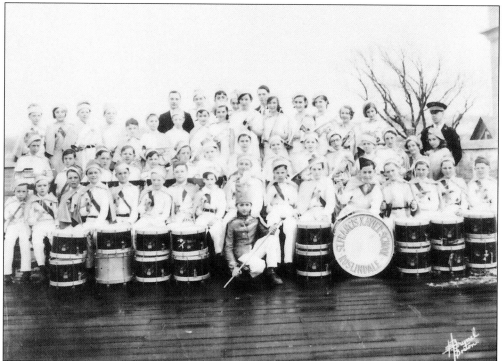

The band of Sacred Heart Church poses for a group photograph in 1935. (Courtesy of the Sacred Heart Church.)

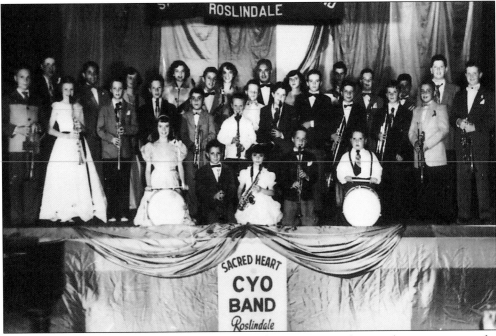

The Sacred Heart Church CYO Band presented an evening of musical entertainment for parishioners in the school hall in 1949. (Courtesy of the Sacred Heart Church.)

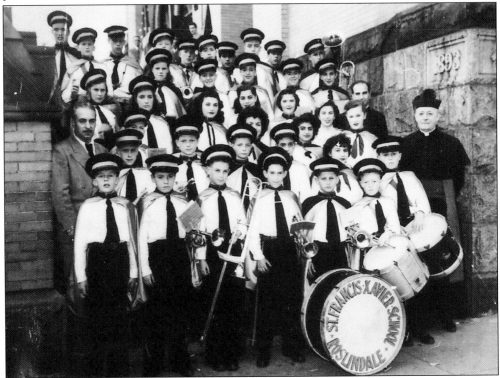

An early photograph of the band shows the members on the steps of the church about 1945. (Courtesy of the Sacred Heart Church.)

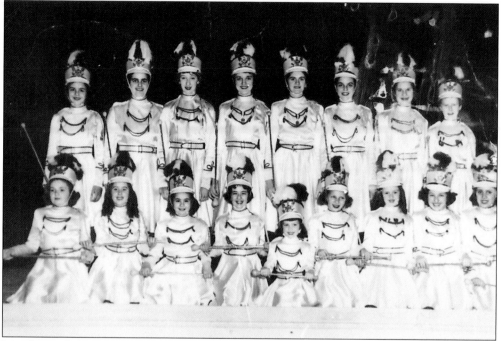

Members of the original drill team pose for their photograph in 1950. (Courtesy of the Sacred Heart Church.)

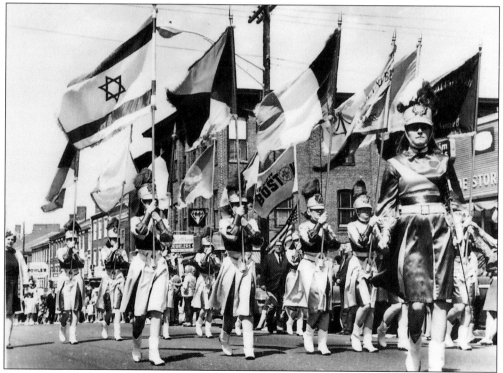

The drill team and the CYO band were always a big hit when they participated in a parade. Hold those flags high! (Courtesy of the Sacred Heart Church.)

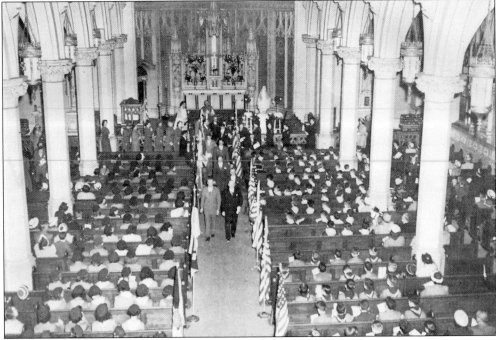

In 1950, the second annual Solemn Investure of the CYO Boy and Girl Scouts to Our Blessed Mother took place at the Sacred Heart Church. (Courtesy of the Sacred Heart Church.)

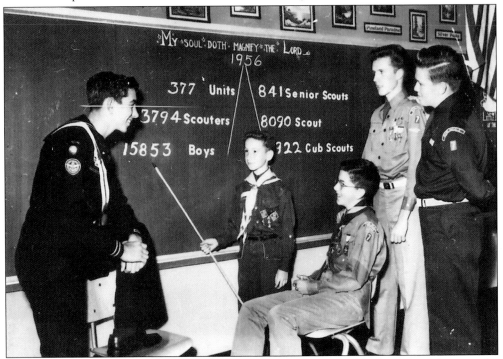

These boys, who belonged to the pack from Sacred Heart Church, are explaining the "trickle down theory" of Senior Scouts, Scouts, and Cub Scouts in 1956. (Courtesy of the Sacred Heart Church.)

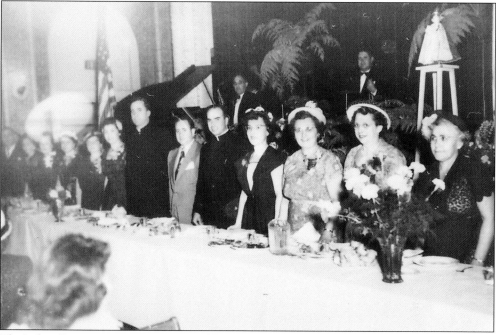

The Italian Society was an active group of the Sacred Heart Church. Here, officers stand at the head table as the priest offers the blessing before dinner. (Courtesy of the Sacred Heart Church.)

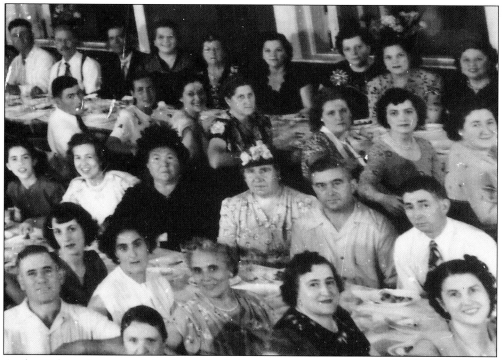

At the 10th anniversary celebration of the Italian Society, every seat was taken by members and friends attending the gala banquet. (Courtesy of the Sacred Heart Church.)

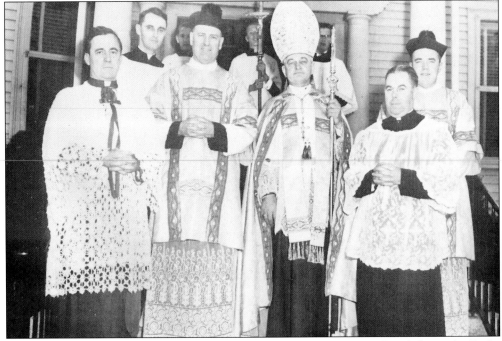

Shown here attending confirmation at Sacred Heart Church in 1956 are, from left to right, Right Reverend Edward J. Murray, Reverend Frederick Mc Manus, Reverend Thomas F. Wilkinson, Bishop Jeremiah Minihan, Reverend Fabian J. Sammon, and Reverend Thomas P. Coffey. (Courtesy of the Sacred Heart Church.)

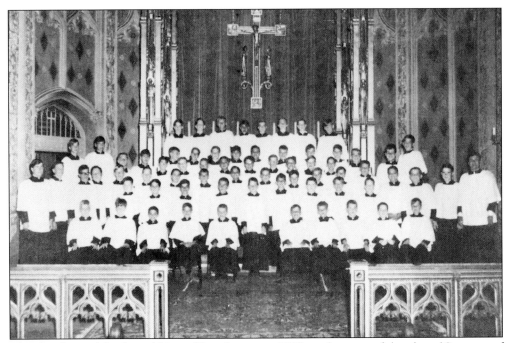

The altar boys of the Sacred Heart Church pose in 1968 on the steps of the altar. (Courtesy of the Sacred Heart Church.)

A new spire was added to the tower of the Sacred Heart Church in the early 1950s. (Courtesy of the Sacred Heart Church.)

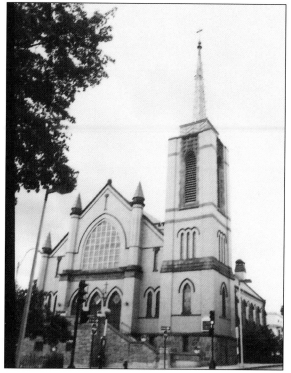

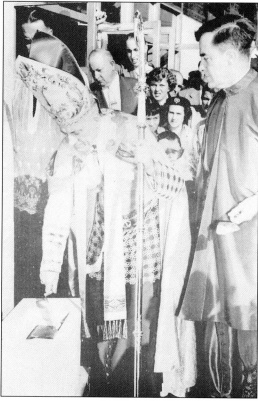

Richard Cardinal Cushing laid the cornerstone of the Sacred Heart School on Canterbury Street in October 1954. (Courtesy of the Sacred Heart Church.)

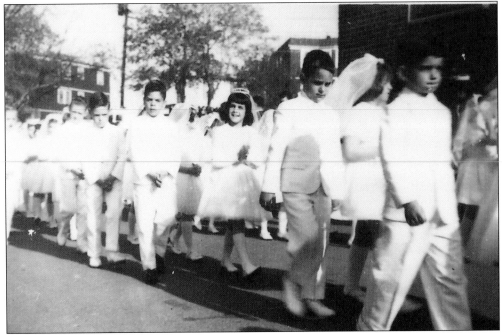

First communicants walk in the May procession in the early 1960s. These May processions would wind their way out of the church, through the surrounding streets, and then return for an afternoon service. (Courtesy of the Sacred Heart Church.)

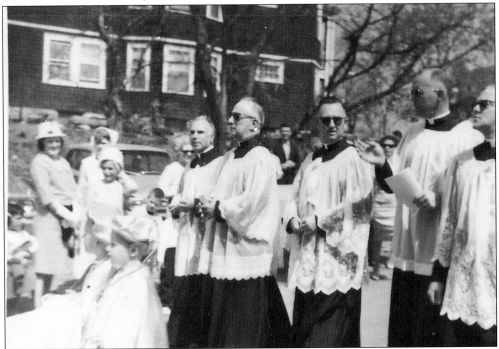

The priests of the Sacred Heart Church would lead the May processions, followed by those who had recently made their first holy communion, those who were recently confirmed, and the members of the CYO. (Courtesy of the Sacred Heart Church.)

Five

Schools

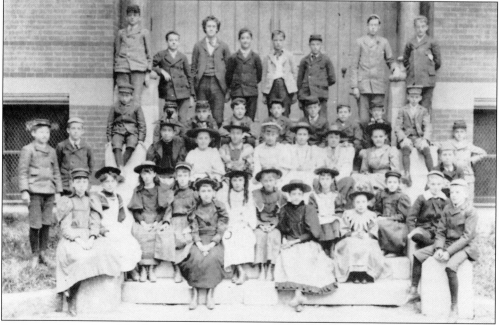

Students of the Ann Hutchinson School pose for their class portrait on the school steps in 1893. Their teacher, third from the left in the last row, seems almost as young as his students. (Courtesy of the BPL.)

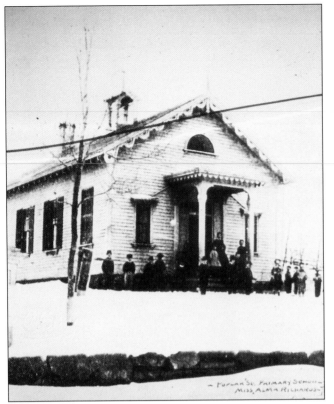

The Poplar Street Primary School was opened in 1863. Miss Alma Richards was the first teacher in this Italianate one-room schoolhouse. (Courtesy of the Roslindale Historical Society.)

Pupils and their teacher at the Poplar Street Primary School pose for their class portrait in 1889.

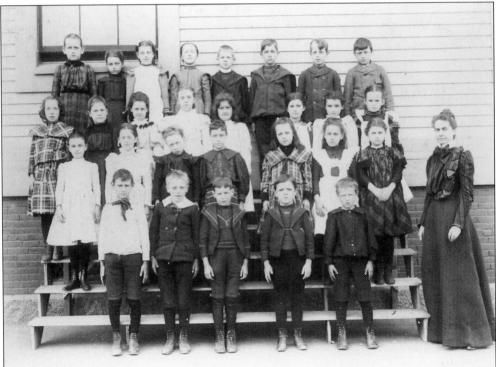

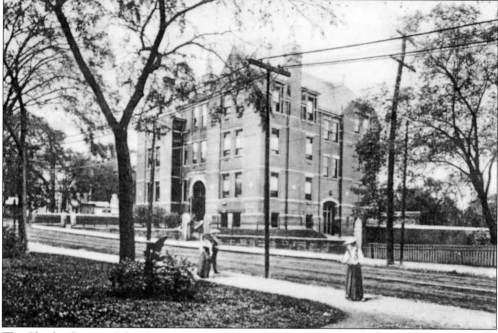

The Charles Sumner School was built in 1872 on Ashland Street (now Cummins Highway), on the present site of the post office.

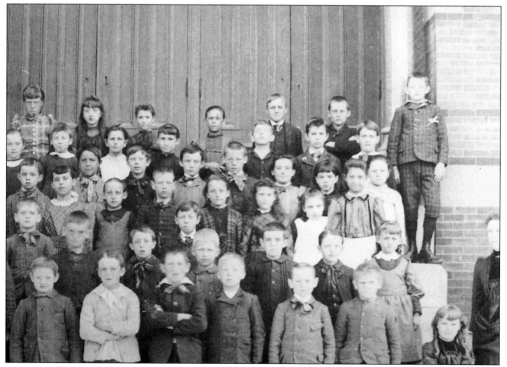

Students of the Charles Sumner School pose for their class portrait in 1891 on the steps of the school. (Courtesy of the BPL.)

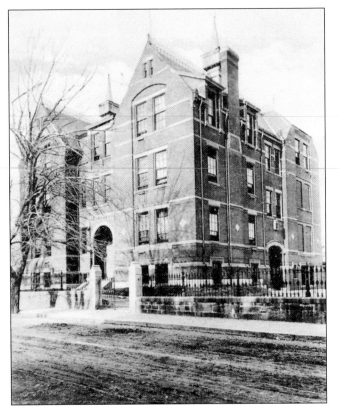

A three-story brick and granite schoolhouse, the Charles Sumner School was named for Charles Sumner (1811–1874), a staunch abolitionist and a noted U.S. senator from Massachusetts. Sumner's fierce opposition to slavery led to his beating in 1856 on the floor of the Senate. A new Sumner School was built in 1931 on Basile Street in Roslindale.

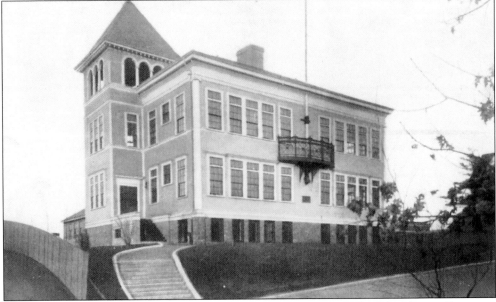

The original Phineas Bates School was built on Beech Street in Roslindale. Phineas Bates was secretary of the Boston School Committee from 1879 to 1896; the present Bates School was built in 1929 and was designed by the architectural firm of Newell & Blevins.

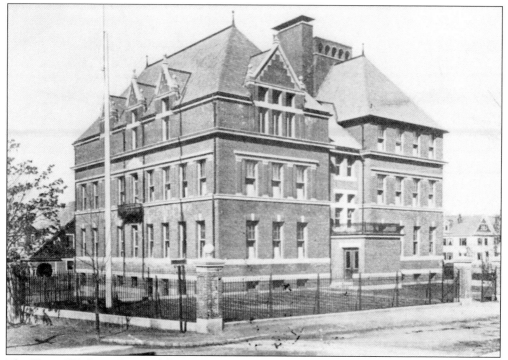

The Henry Wadsworth Longfellow School was built in 1897 on South Street in Roslindale and designed by the architectural firm of Walker & Kimball.

Henry Wadsworth Longfellow (1807–1882) was a noted poet who lived on Brattle Street in Cambridge, Massachusetts. His poems, including *Paul Revere's Ride*, *The Courtship of Myles Standish*, and *The Song of Hiawatha*, have been memorized and recited by generations of students.

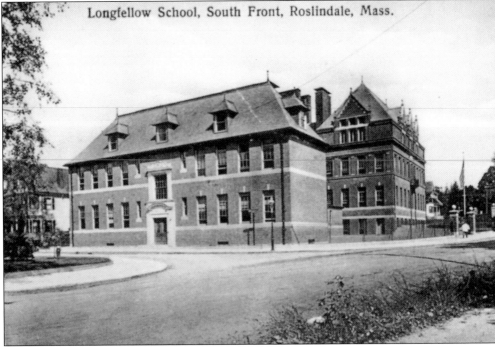

The Longfellow School was enlarged in 1910 with an addition to the south front of the school on Farquhar Street.

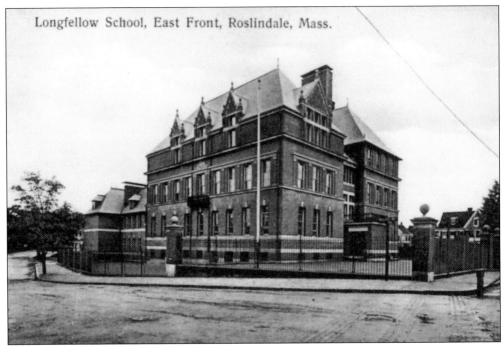

The 1897 design of Walker & Kimball incorporates a sophisticated design with a massive slate roof punctuated by fanciful dormers. Today, the Longfellow School unfortunately stands vacant, awaiting reuse by the community.

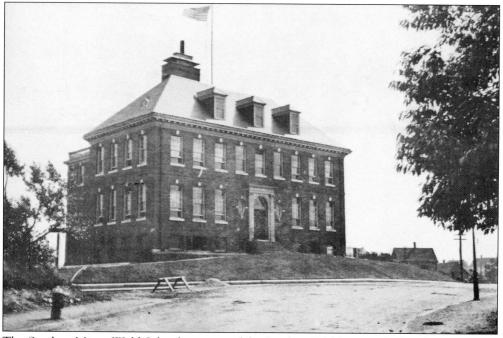

The Stephen Minot Weld School was named for Stephen Weld, a noted educator who kept a private boys' school in Jamaica Plain, Massachusetts, in the mid-nineteenth century.

The Washington Irving School on Cummins Highway was named for the noted author of *Rip Van Winkle* and *The Legend of Sleepy Hollow*. Irving (1783–1859) was an attorney and one-time ambassador to Spain who spent much of his life writing stories which are still appreciated today. The school was built in 1936 and was designed by Sturgis Associates.

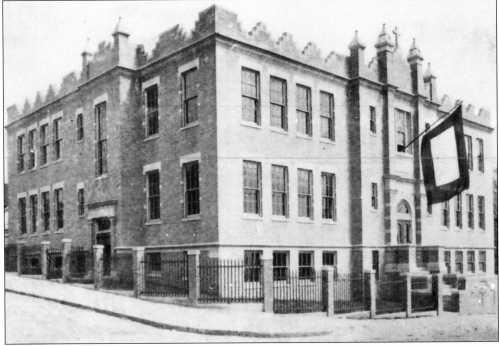

Saint Francis Xavier School was the first parish school of the Sacred Heart Church. The building later became Saint Clare's High School, which was founded in 1955. (Courtesy of the Sacred Heart Church.)

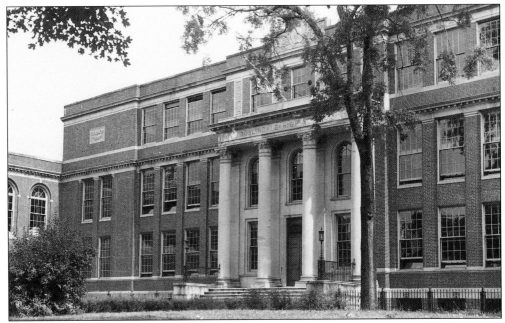

Roslindale High School was built on Poplar Street between 1922 and 1926. After serving as the senior high school for five decades, it was remodeled as Florence House, a senior citizen condominium residence. (Courtesy of Claude Mac Gray.)

Members of the 15th graduation class of Saint Clare's High School stand during graduation ceremonies in the school hall in 1970. Sister Helene Byrne, principal, extolled the virtues of education and the future role of the students in the community. (Courtesy of Jeannette Ashe.)

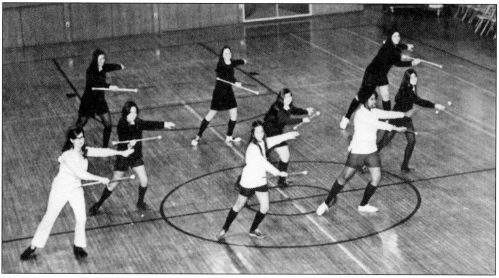

Twirling their batons in the gymnasium at Saint Clare's High School are, from left to right, as follows: (front row) Miss O'Neill (moderator), Regina Donovan, and Lynn Moore; (middle row) Judy Gorman, Jeannette Ashe, and Patricia Gatto; (back row) Patricia Riley, Kathleen Nocca, and Jane Maguire. (Courtesy of Jeannette Ashe.)

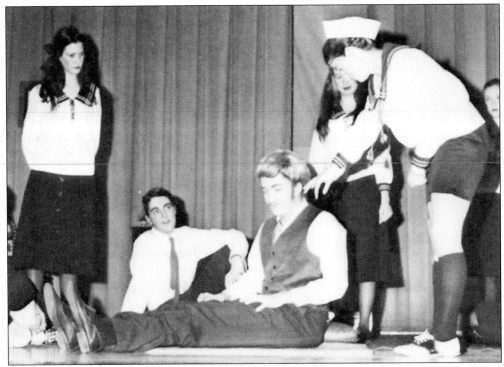

The cast members of Saint Clare's 1970 senior play, *Cheaper By the Dozen*, included, from left to right, Kathleen O'Malley, Maureen O'Brien, Diane Wood, and Theresa Burton. In the rear are Rosemarie O'Sullivan and Louise Driscoll. (Courtesy of Jeannette Ashe.)

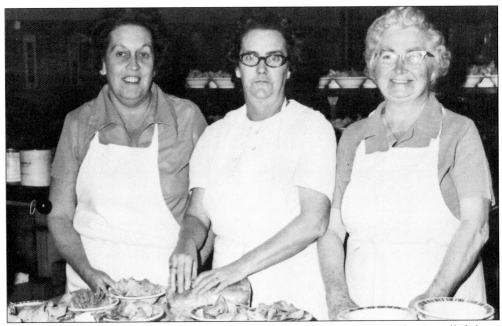

These three smiling cafeteria workers who kept the students at Saint Clare's well fed are Theresa Gribaudo, Helen Jurewich, and Anna Jones. (Courtesy of Jeannette Ashe.)

Six

The Library

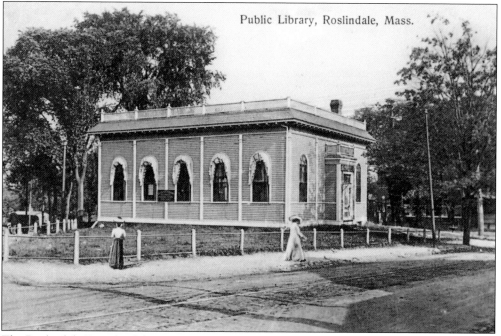

Public Library, Roslindale, Mass.

The Roslindale Branch of the Boston Public Library was first located in the former Taft Tavern in the center of Roslindale Village. Taft Tavern, which had fallen into disuse by the 1870s, was where the City of Boston established a book drop in 1878; the former tavern was demolished at the turn of the century and a one-story wood-framed library was built in 1904. Two women are shown here passing the Colonial Revival library in 1910.

Frederick William Whiteley was a member of the Boston City Council in 1900 and 1901 and "had a part in securing for the district the Branch Public Library at Roslindale." An active member of the Roslindale Citizens' Association, he was "attentive to the duties of his office and many improvements came to the district through his efforts." (Courtesy of the BPL.)

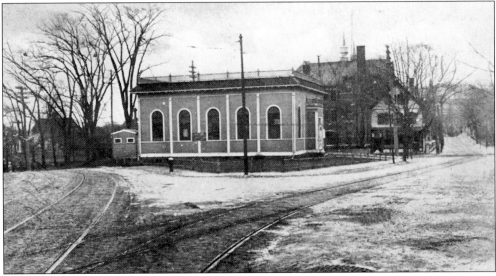

The Roslindale Branch of the Boston Public Library was opened in 1904 in Roslindale Village at the corner of Poplar and South Streets in what is now Adams Park. Ashland Street (now Cummins Highway) can be seen on the right. The library later moved to the municipal building in 1918 and for several years had the largest branch library circulation in Boston.

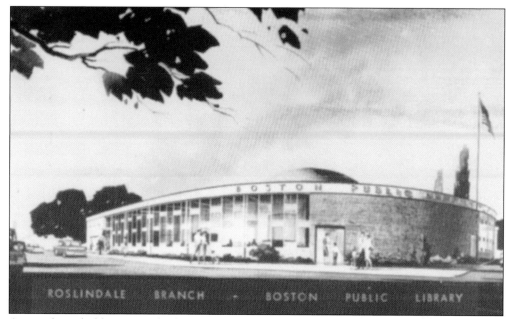

A new branch library was built in 1961 at the corner of Washington and Poplar Streets. Designed by Isador Richmond and Carney Goldberg, it is a distinctly postmodern library with dramatically curved walls and massive expanses of plate glass windows. The building provided space for a children's section, a young adults' section, and an adults' section.

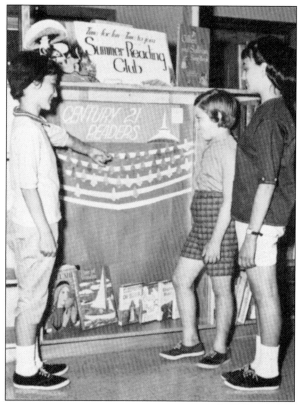

"Getting Into Orbit" was the theme for the Summer Reading Club at the Roslindale library in 1962. Showing her "space capsule" (books read by individual members) is Marie Trevisani on the left, accompanied by friends Patricia Belmonte and Marguerite Amico. (Courtesy of the BPL.)

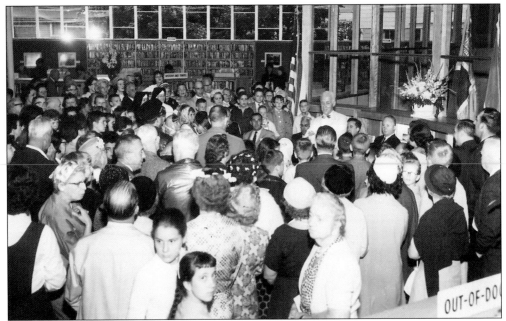

The opening of the new Roslindale Branch of the Boston Public Library took place on September 15, 1961. Milton Lord, director of the Boston Public Library, speaks to the audience as trustees Sidney Rabb, Right Reverend Edward Murray, Erwin Canham, Patrick McDonald, and Augustin Parker look on. (Courtesy of the BPL.)

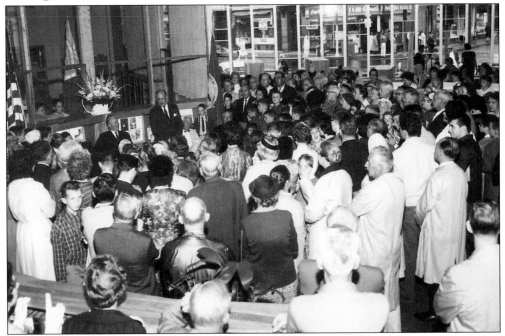

Sidney R. Rabb, president of the Trustees of the Boston Public Library in 1961, welcomes neighborhood residents to the opening of the new library. John F. Collins, mayor of Boston, can be seen seated just below the floral arrangement on the left, listening to Mr. Rabb's remarks. (Courtesy of the BPL.)

Seven

Public Works and the Bussey Bridge Disaster

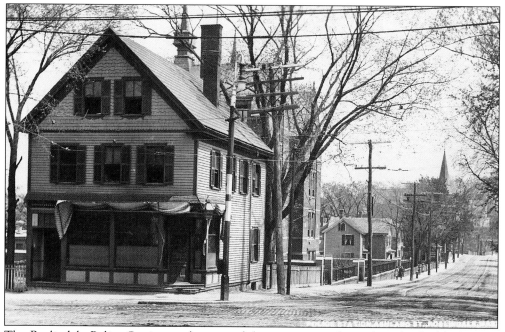

The Roslindale Police Station at the turn of the century was located in this building at the corner of Washington Street and Ashland Street (now Cummins Highway). The local station was under the jurisdiction of Station 13 in Jamaica Plain and had fourteen patrolmen in 1905. The facade of the Charles Sumner School can be seen just behind the police station.

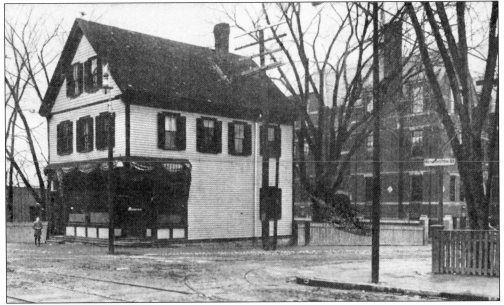

The Roslindale Police Station was originally a wood-framed house that was converted to a police station in the 1890s. Due to the length of the "beats" walked by the patrolmen, bicycles were used to a considerable extent to save on shoe leather. (Courtesy of Claude Mac Gray.)

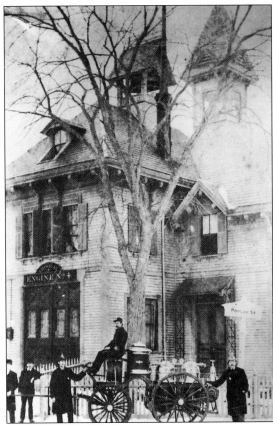

Chemical Engine 4 was located on Poplar Street in Roslindale. Firemen pose with the chemical fire engine in front of the firehouse about 1890. (Courtesy of the BPL.)

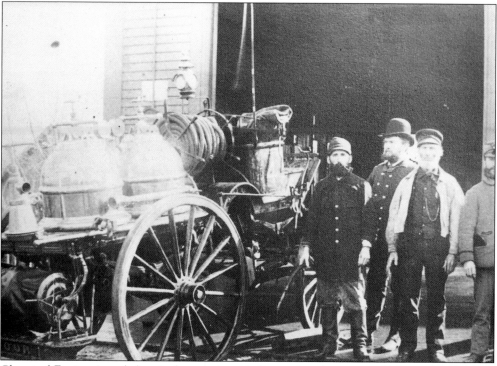

Chemical Engine 4 used chemicals to extinguish fires rather than water. Volunteers, who were eventually replaced by permanent members of the Boston Fire Department, pose beside the engine in 1888. (Courtesy of the Roslindale Historical Society.)

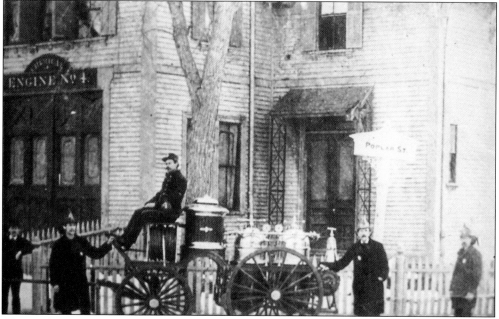

Chemical Engine 4 had massive doors that opened onto Poplar Street. The firemen could relax on the second floor and then dress quickly and slide down the brass pole when the fire alarm sounded. (Courtesy of the Roslindale Historical Society.)

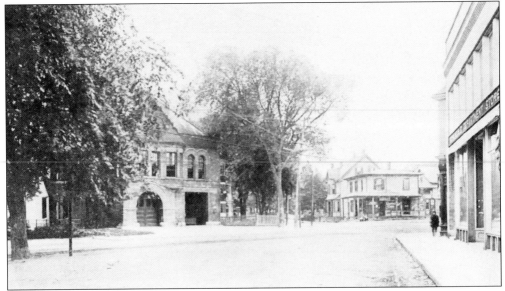

Engine 45 and Ladder 16 were located on Washington Street at the corner of Poplar Street in Roslindale Village. On the right is the Roslindale Department Store, which was on Corinth Street facing Adams Square. (Courtesy of Claude Mac Gray.)

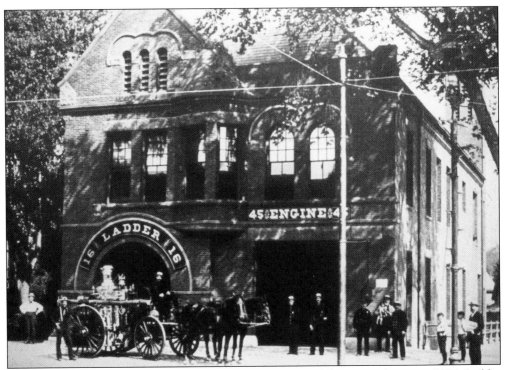

Chemical Engine 45 poses, complete with horses, in front of the engine house in 1895. Ladder companies evolved as buildings became taller, making ladders a necessity. (Courtesy of the Roslindale Historical Society.)

The Roslindale Firehouse (which housed Chemical Engine 45 and Ladder 16) was an impressive Romanesque Revival building, complete with a weather vane in the design of a horse-drawn fire engine.

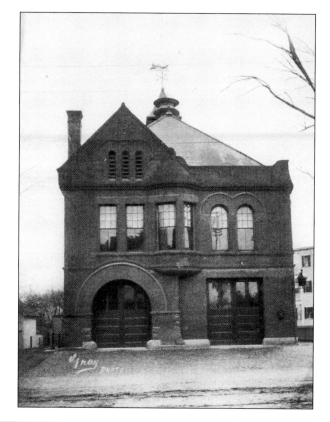

Firemen, adult residents, and young boys pose in front of Engine 45's firehouse at the turn of the century. A bearded gentleman holds the mascot of the firehouse. (Courtesy of the Roslindale Historical Society.)

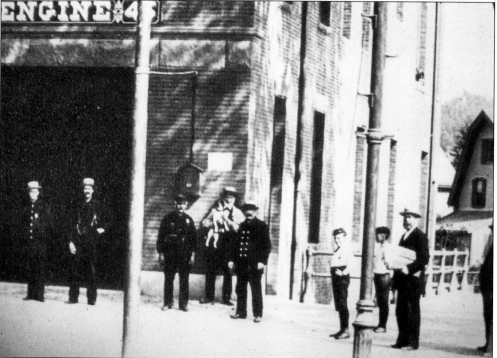

A stone bridge was built on the Bussey Estate to allow the Boston and Providence Railroad to be put through to Roslindale. The arch of the bridge led to the naming of the street "Archdale Street." This scene was captured near Puritan Ice Cream on Washington Street. (Courtesy of the Roslindale Historical Society.)

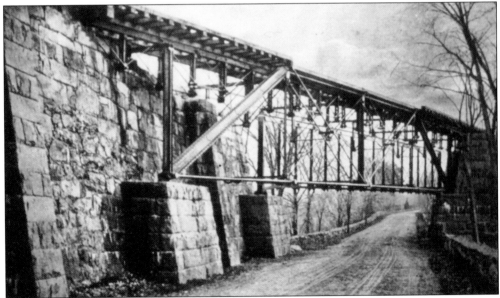

When the railroad was laid out, the tracks had to be laid at a precarious angle as Harvard College would not allow trees to be cut down on the former Bussey Estate, which was bequeathed to the college by Benjamin Bussey in 1842. The bridge was rebuilt in 1876 with stone piers at either end to support the tracks, which crossed at a sharp angle. (Courtesy of the Roslindale Historical Society.)

The bridge eventually proved to be unstable, since iron loses its strength with the constant motion of trains passing over the tracks. On March 14, 1887, at about 7:20 am, the Bussey Bridge collapsed, hurdling passenger coaches into the chasm between the stone piers, killing 30 passengers and injuring 115. (Courtesy of the Roslindale Historical Society.)

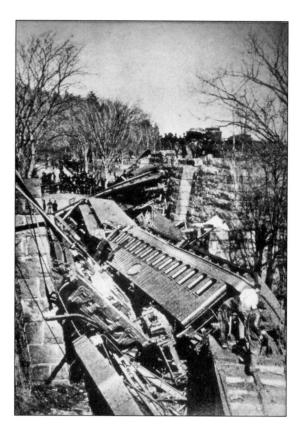

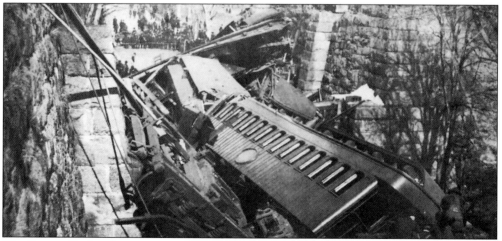

The Bussey Bridge disaster is considered the first major railroad catastrophe in the United States and it led to the inspection of train bridges across the country. After The Torrey (the engine) and the coal car cleared the bridge, the span collapsed and the remaining coaches fell and splintered like matchwood, trapping the injured and dead until help could be summoned. Engineer Walter White continued on to Forest Hills, blasting his whistle to summon help. (Courtesy of the BPL.)

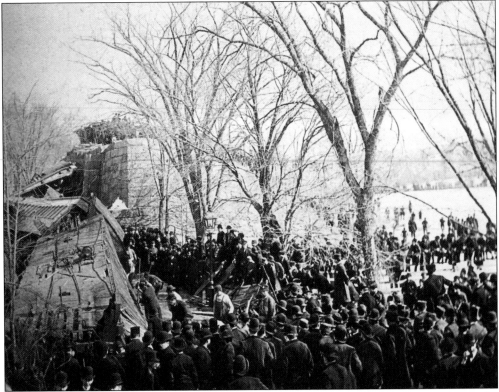

Thousands of anxious area people ran to the scene of the Bussey Bridge Disaster to render assistance. (Courtesy of the Roslindale Historical Society.)

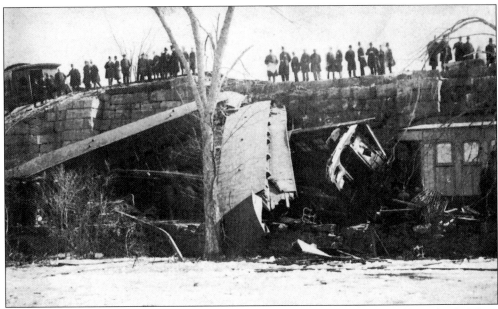

Men stand on the stone wall and peer down at the passenger coaches that had been hurled from the tracks and were wedged against one another. (Courtesy of the BPL.)

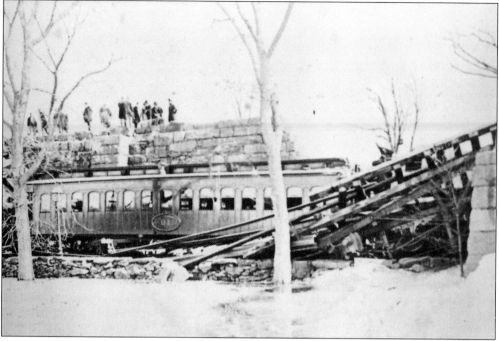

Looking down at the wreckage, the curious stand on the stone pier of the Bussey Bridge. (Courtesy of the BPL.)

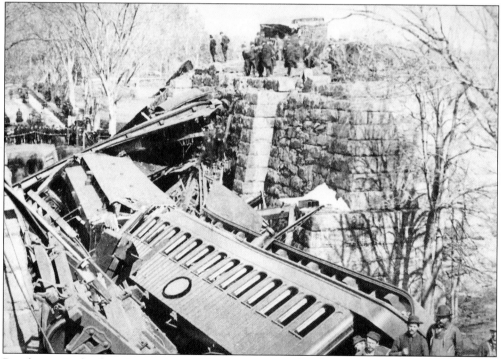

People gaze in shock at the wreckage of the passenger coaches from the ruins of the Bussey Bridge. Notice how the area is roped off, holding the curious onlookers at bay. (Courtesy of the BPL.)

Frederick George Child opened a photograph studio at 50 and 52 Ashland Street (now Cummins Highway) at the corner of Florence Street in 1893. It was said of him that his "wide and thorough experience in all departments of photography has been of great advantage, and his work is recognized to be of a high standard." (Courtesy of the BPL.)

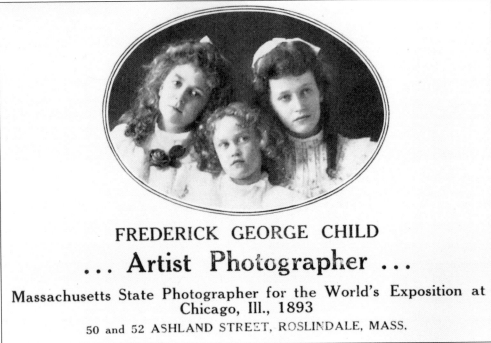

FREDERICK GEORGE CHILD

... Artist Photographer ...

Massachusetts State Photographer for the World's Exposition at Chicago, Ill., 1893

50 and 52 ASHLAND STREET, ROSLINDALE, MASS.

Child, the "Artist Photographer," advertised in the *Roxbury Blue Book* in 1909. (Courtesy of Stephen D. Paine.)

Eight

The Neighborhood

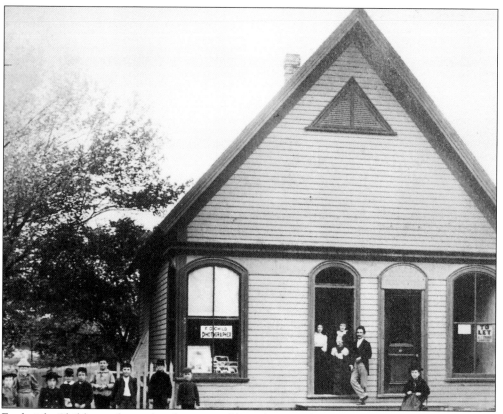

Frederick Child stands in the doorway of his photograph studio on Ashland Street (now Cummins Highway) in 1904. Neighborhood children stand at attention for the photographer on the left. (Courtesy of the Roslindale Historical Society.)

Albano Street, which was laid out in 1852, runs from Roslindale Avenue to Washington Street. (Courtesy of the Roslindale Historical Society.)

John T. Hosford lived at 346 Belgrade Avenue and was a real estate agent in Roslindale, Roxbury, Jamaica Plain, and West Roxbury. (Courtesy of the BPL.)

Belgrade Avenue, looking toward Roslindale Square in 1900, had undeveloped stretches of land on the right at the turn of the century. (Courtesy of the Roslindale Historical Society.)

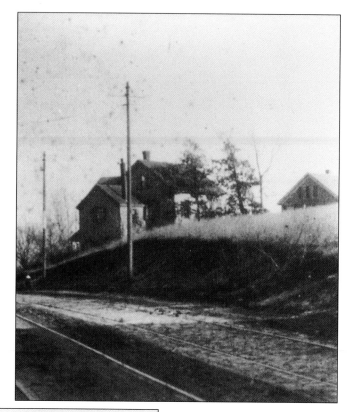

Belgrade Avenue, looking toward Walworth Street in 1900, had trolley tracks running in the center of the street for the streetcars that crisscrossed through Roslindale. (Courtesy of the Roslindale Historical Society.)

Brown Avenue, laid out in 1847 and originally called Alpine Avenue, runs from the junction of Ridge and Florence Streets to Poplar Street. It has been known as Brown Avenue since 1869.

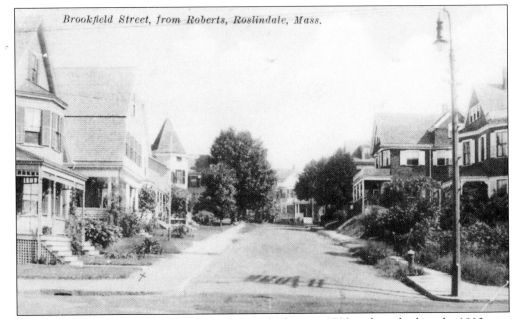

Brookfield Street, seen from Roberts Street, was laid out in 1893 and was built up by 1910.

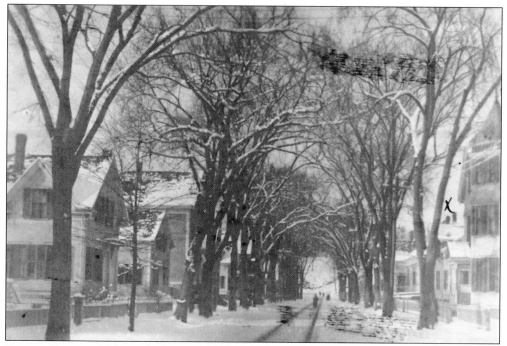

Conway Street, which was laid out in 1885, runs from Fairview Street to South Street.

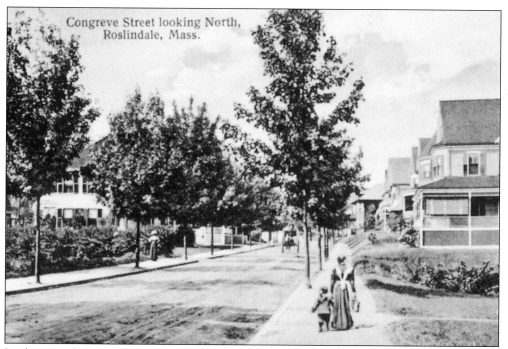

Congreve Street looking North, Roslindale, Mass.

Looking north on Congreve Street about 1905, a woman and child pass large houses built at the turn of the century.

George E. Gray was the proprietor of Gray's Highland Studio, "one of the most modern and up-to-date galleries" in Boston at the turn of the century. He also served as president of the Roslindale Citizens' Association in 1899. (Courtesy of the BPL.)

Gray built his Colonial Revival house at 16 Congreve Street. (Courtesy of the BPL.)

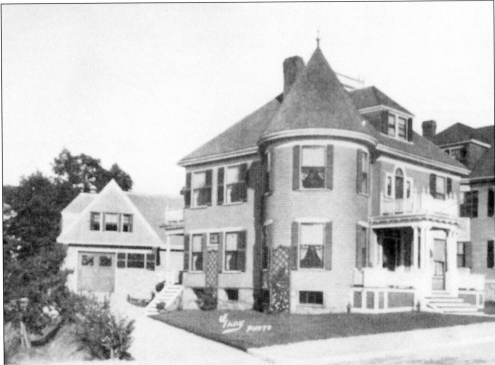

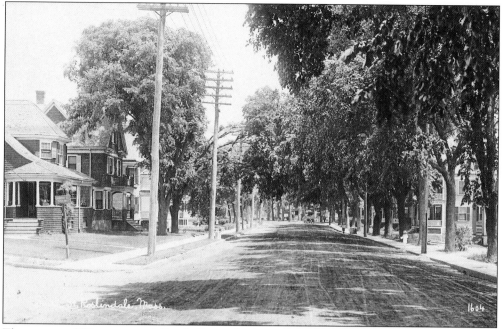

The corner of Edgemont and South Streets had an alley of shade trees that created a bucolic setting for these large Victorian houses. (Courtesy of Claude Mac Gray.)

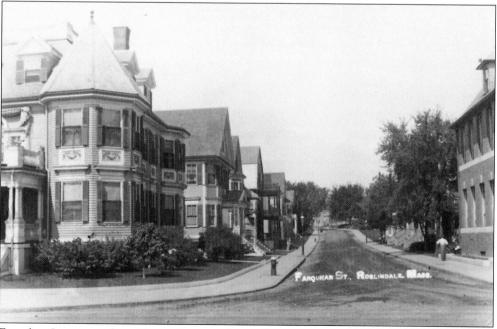

Farquhar Street runs from Centre Street to South Street.

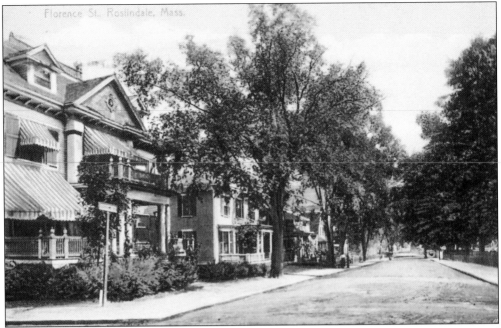

Numbers 2, 8, and 12 Florence Street were large Colonial Revival houses with front lawns and shade trees offering respite from the summer sun.

Florence Street, which was laid out in 1848, runs from Poplar Street to Ridge Street, where it turns and becomes Brown Avenue.

Edward J. Bromberg served as state senator and was "a faithful, constant and energetic champion of all improvements in the West Roxbury District, has been closely identified with the long siege and the successful victory for better transportation facilities, the procuring of the present mantle boulevard street lamps in place of the old-fashioned naphtha lights, the very many new sewers, better streets, sidewalks, gutters and the numerous other local improvements."

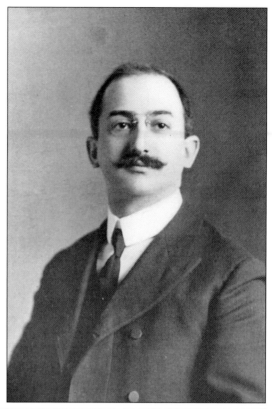

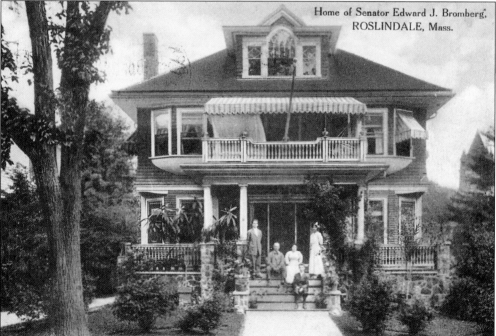

Senator Bromberg lived at 12 Florence Street. He is shown here about 1909 posing for a photograph with his wife and their children.

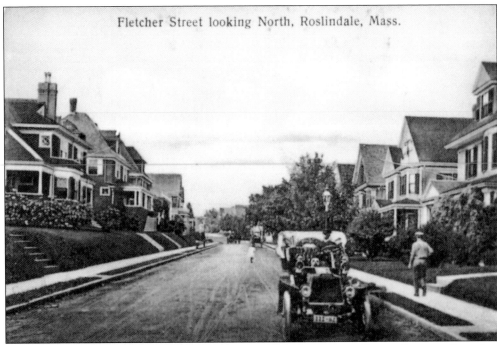

Fletcher Street looking North, Roslindale, Mass.

Looking north on Fletcher Street, which runs from South Street to Centre Street, a "horseless carriage" passes well-kept houses that were built after the street was laid out in 1896.

A woman and children walk through snow on Hewlett Street at the turn of the century. Hewlett Street, laid out in 1893, runs from Centre Street to Walter Street. (Courtesy of the BPL.)

The residence of
Sybil W. Weld was a large
mansion set on extensive
grounds on Wyvern Street.
The estate remained
open and undeveloped
until the 1920s.
(Courtesy of the BPL.)

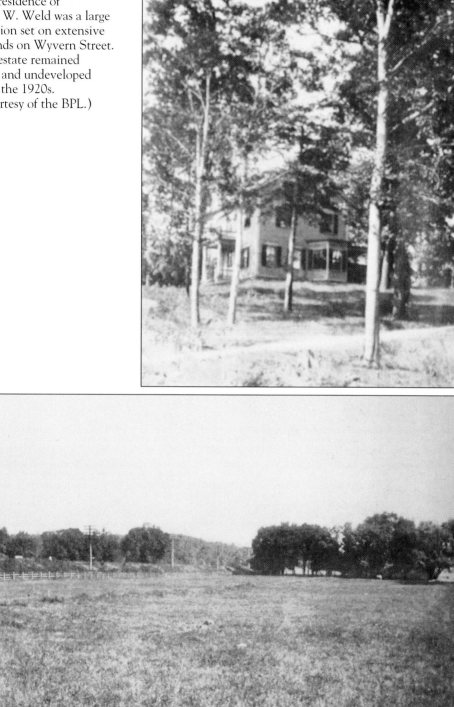

The rolling lawns of the Weld Estate are shown in this view from Hyde Park Avenue with
Hemlock Hill in the distance. This area is now roughly 391 Hyde Park Avenue in Roslindale.
(Courtesy of the BPL.)

Hyde Park Avenue, which was laid out between 1843 and 1849, was being graded in 1904 when this photograph was taken. To the right is 1108 Hyde Park Avenue, set high up on a hill. (Courtesy of the Roslindale Historical Society.)

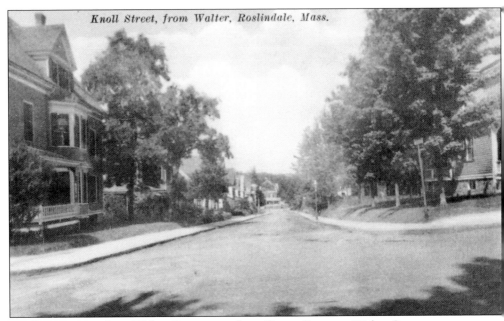

Knoll Street, from Walter, Roslindale, Mass.

Knoll Street, seen from Walter Street, runs from Centre Street to Walter Street.

Clarence W. Packard lived in this house at 96 Newburg Street. Notice the wood planking that was laid over the walks in anticipation of winter snowstorms.

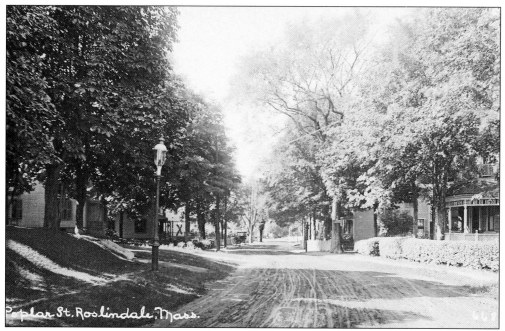

Poplar Street was laid out in 1825 and was still unpaved when this turn-of-the-century photograph was taken. Notice the carriage wheel ruts and the gas street lamp. (Courtesy of Claude Mac Gray.)

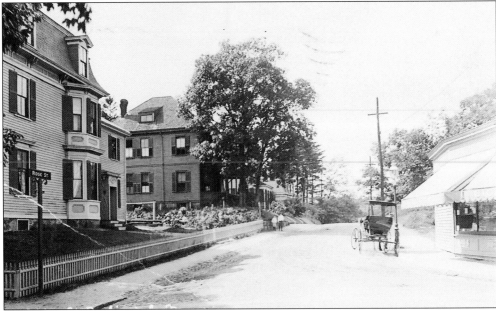

Ridge Street was laid out in 1888 and runs from Brookdale Street to Brown Avenue.

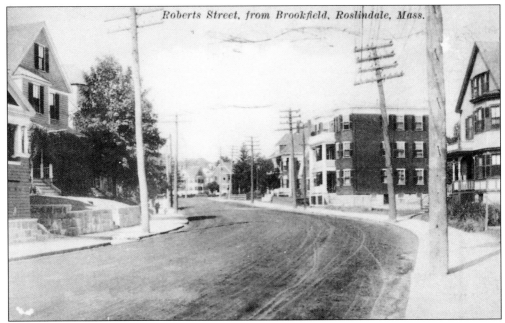

Roberts Street, seen from Brookfield Street, had a wide array of housing stock, from single-family Victorians to three-deckers.

Jean P. Nickerson lived at 381 Hyde Park Avenue and was "secretary of the original Five Cent Fare Executive Committee, secretary of the Extension of the Elevated Executive Committee, [and] a member of the Roslindale Citizens' Association." He was also, at the turn of the century, president of the Mount Hope Citizens' Association. (Courtesy of the BPL.)

Jean P. Nickerson's house was set well back from Hyde Park Avenue. An attorney, his "life work has been journalism, and he has done special newspaper work for daily papers from Maine to Oregon." (Courtesy of the BPL.)

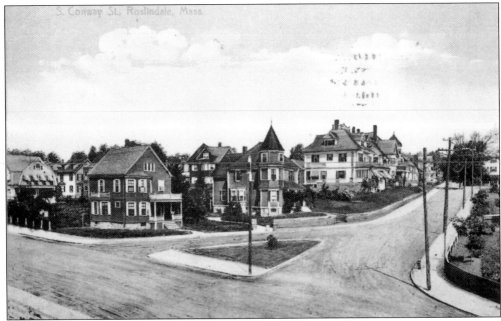

South Conway Street runs from Fairview Street to Conway Street.

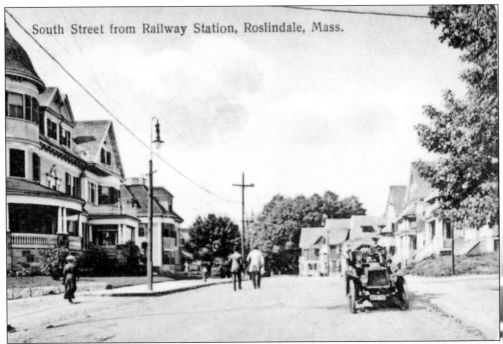

South Street, seen from the Roslindale Railway Station on the Boston and Providence line, still has substantial Colonial Revival houses. Laid out in 1662, South Street ran from Eliot Square in Roxbury to Centre Street.

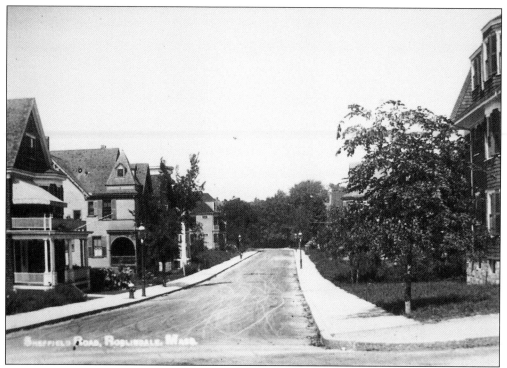

Sheffield Road (now Street) runs from Walter to Selwyn Street. (Courtesy of the Roslindale Historical Society.)

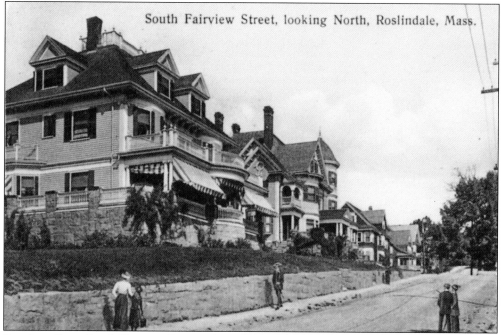

South Fairview Street, looking North, Roslindale, Mass.

People walk on South Fairview Street, where most of the large houses are set up high on a stone retaining wall. Laid out in 1895, the street runs from Walter Street to Fairview Street, and it abuts Fallon Field.

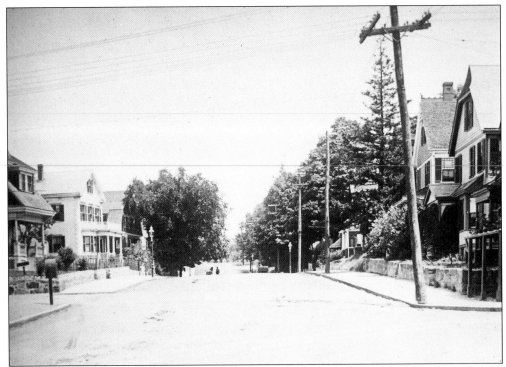

Walter Street, named for Reverend Nehemiah Walter, is one of the oldest streets in Roslindale, running from South Street to the Arnold Arboretum. The old Walter Street Cemetery is located near Center Street, and was laid out in 1711. (Courtesy of the Roslindale Historical Society.)

Washington Street is one of the longest streets in the Commonwealth of Massachusetts. Extending from Boston to the Rhode Island border, it was originally called the Dedham Turnpike in Roslindale.

Nine

Transportation

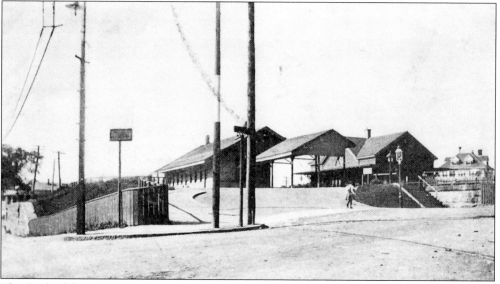

The Roslindale station was a stop on the Boston and Providence Railroad line and was near Roslindale Village on South Street. Laid out in 1834, the Boston and Providence Railroad opened a new line that split at Forest Hills and stopped at Roslindale Village, Central (later Bellevue), West Roxbury Village, and Spring Street. The accessibility of Roslindale to Boston brought many new residents to the town in the nineteenth century.

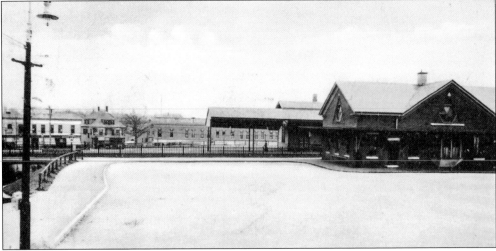

Seen here from the turnabout toward South Street, the station and covered waiting platform were elevated above street level so that traffic could pass under the train tracks.

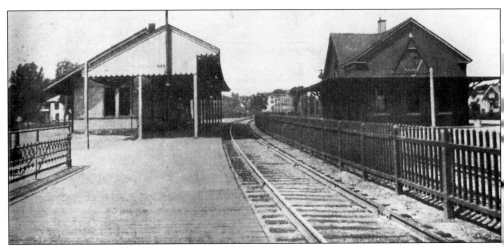

The platforms and covered waiting areas at the Roslindale station were located on either side of the tracks. (Courtesy of the BPL.)

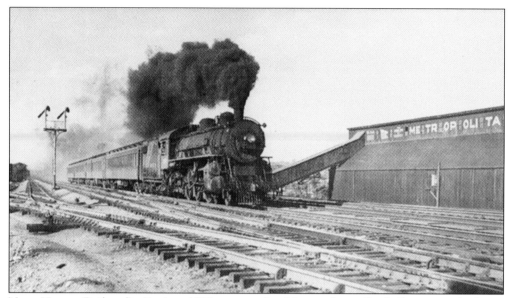

New Haven Railroad's Engine 1300 passes the Metropolitan Coal Company sheds on Washington Street in the 1930s. The engine pulled four passenger coaches that ran from Providence, Rhode Island, to Boston. Unfortunately, the service was discontinued in 1979, but through persistent efforts, the Roslindale station has been reopened for passenger service. (Courtesy of the Roslindale Historical Society.)

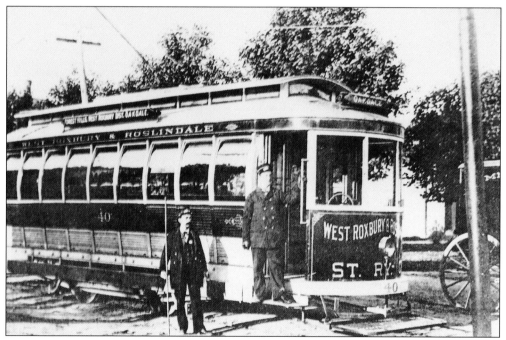

Streetcars connected the Forest Hills station on the Boston Elevated Railway to points in Roslindale and West Roxbury via the West Roxbury and Roslindale Street Railway. Two conductors stand beside a streetcar headed for Oakdale Square in Dedham, Massachusetts. (Courtesy of the Roslindale Historical Society.)

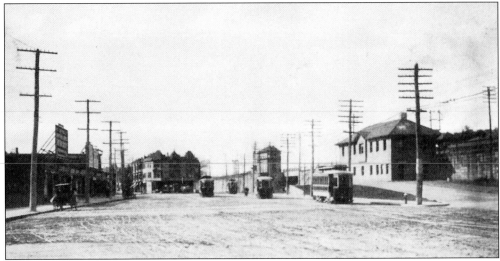

The Forest Hills station was built in 1909 and was the terminus of the Boston Elevated Railway. Connecting Forest Hills and Sullivan Square in Charlestown via the "El," the streetcars in the foreground would bring passengers from Roslindale and West Roxbury to the terminal.

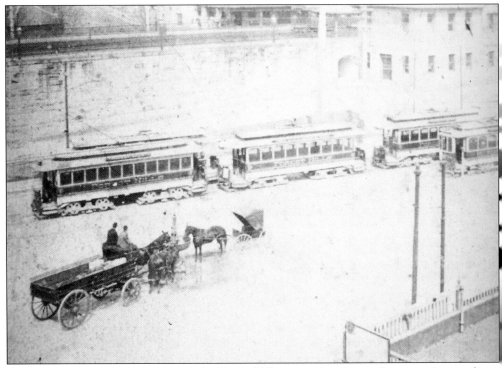

Streetcars are awaiting passengers at the Forest Hills station as a horse-drawn carriage and cart pass on Washington Street. (Courtesy of the Roslindale Historical Society.)

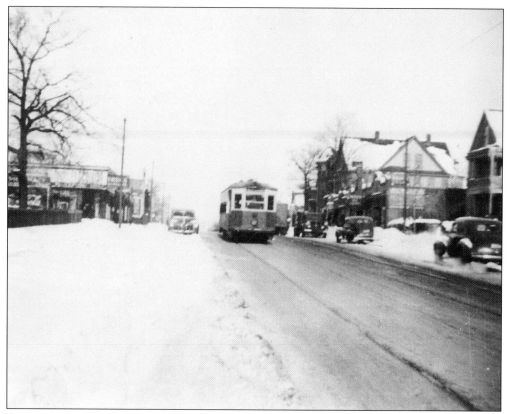

A streetcar passes the corner of Mount Hope and Hyde Park Avenues about 1945. On the left is Sellen's Drug Store. (Courtesy of the BPL.)

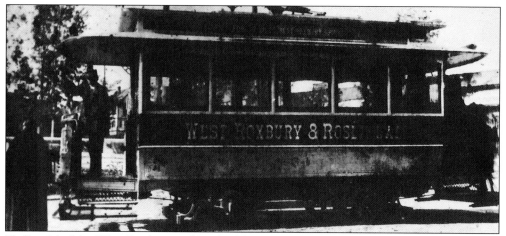

Trolley 34 of the West Roxbury and Roslindale Street Railway made it possible for people who lived in the suburbs to commute into town for business and shopping. Note the woman walking to the trolley on the left. (Courtesy of the BPL.)

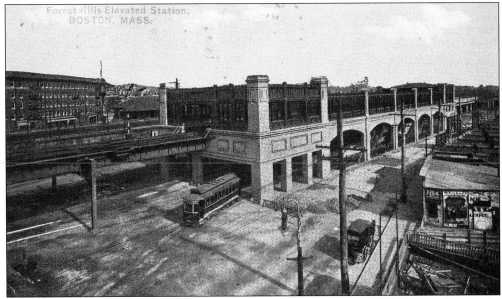

The Forest Hills station is still the last stop on the Orange Line of the MBTA, but at the time it was built in 1909, it was constructed of reinforced concrete and iron with hand-crafted copper embellishments. As many of the stations on the Elevated Railway were designed by Alexander Wadsworth Longfellow (1854–1912), there is no reason to doubt that the original Forest Hills station was constructed according to his plans.

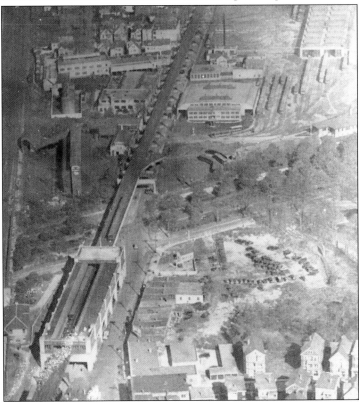

Photographed in 1929, the Forest Hills station was a major stop on the transit route for Jamaica Plain, Roslindale, and West Roxbury residents traveling into Boston.

Ten

Metropolitan Hill

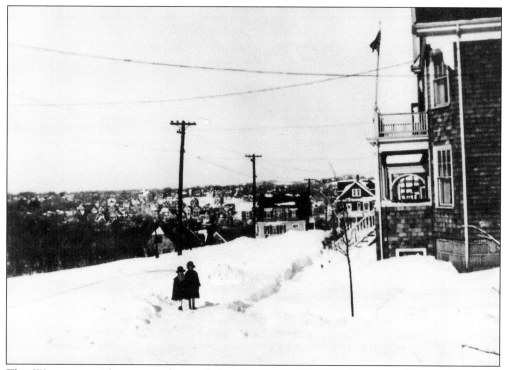

The Waterman girls pose in front of their home at 18 Ethel Street on Metropolitan Hill (sometimes referred to as Clarendon Hill) in Roslindale in 1915. Considered the second highest elevation in Boston (the first being Bellevue Hill), Metropolitan Hill's panoramic views are breathtaking. A snowstorm had recently blanketed Boston with a foot of snow, and the girls stand to the left of a shoveled path in front of their home. (Courtesy of Carol Dieffenbach.)

Metropolitan Hill was bisected by Metropolitan Avenue, which extended from Washington Street in Roslindale and continued through Hyde Park to the Neponset River. Trees were planted along the sidewalk of this residential street as it rose on Metropolitan Hill and intersected with Ethel, Hillburn, Whitford, Poplar, Doncaster, Maynard, Little Dale, Burley, and Vista Streets; Malverna, Rawston, and Chisholm Roads; Augustus, Hillview, and Granada Avenues; Delano and Clarendon Parks; and Highfield and Chisholm Terraces.

Mrs. Baker and her daughter were photographed standing on the porch at 16 Ethel Street in 1913. These gambrel-roofed Shingle Style houses became popular at the turn of the century. Notice the hitching post for horses at the foot of the stairs. The house was purchased by the Johnson family in 1943 and is still home to the family. (Courtesy of Carol Dieffenbach.)

The waterworks building on Metropolitan Hill was photographed on July 2, 1918, with a banner stating that there would be a "Grand Celebration July 4th" hosted by the Metropolitan Hill Improvement Association; the celebration had been held annually since 1913. Notice the streetcar tracks in the foreground. (Courtesy of the BPL.)

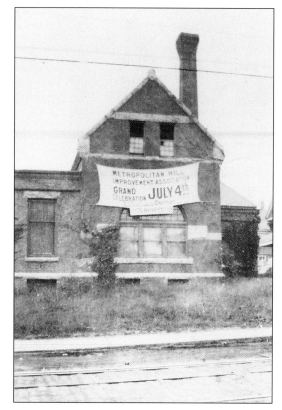

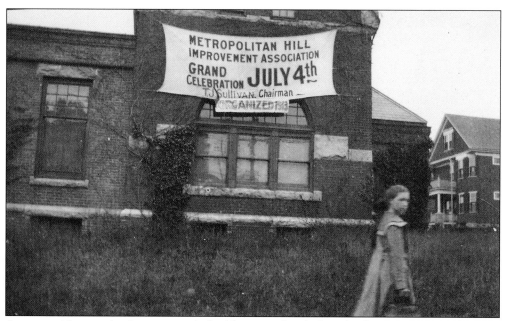

A young girl passes by the waterworks building two days before the festivities were to begin in 1918. (Courtesy of the BPL.)

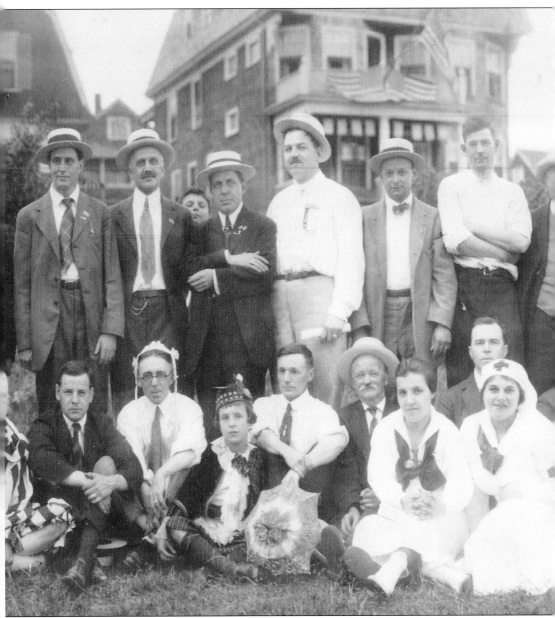

This group photograph was taken on July 4, 1917, of the residents of Metropolitan Hill who participated in the "Horribles Parade." The parade was one of numerous events held to celebrate Independence Day in Roslindale, and hosting participants dressed in a wide array of costumes. An article in the *Parkway Transcript* stated that the participants were dressed "in gala attire marching behind a fantastically garbed drum corps of men and women who were in turn headed by a lone policeman escorted by a group of 'horribles.'" It further stated that the "people of this section have in the past always either held individual celebrations or attended the celebrations in other sections. This year [1917] they pooled their expenditures for the day and with the fund so raised, which was amplified by a small appropriation from the city, they arranged a novel celebration. In the morning there was an interesting programme of sports chiefly for the children. A ball game in which the married men of the district pitted a team against a nine representing

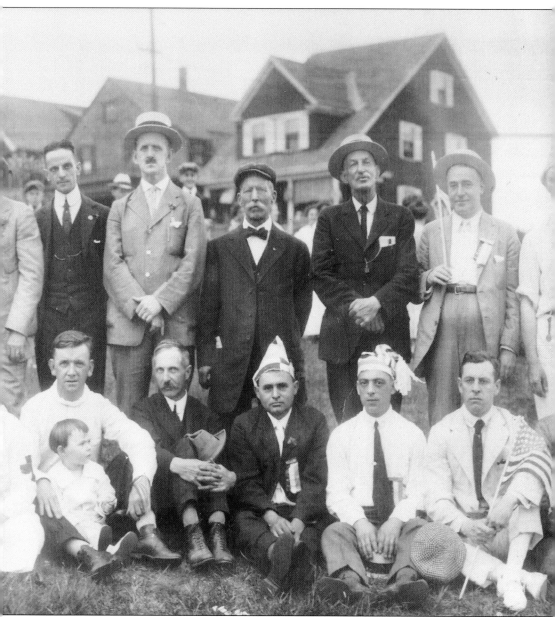

the single men of the district was played. The married women cheered the benedicts while the single girls applauded the bachelors. The parade in which the children, whose ages ranged from 3 to 15 years, assembled upon the lawn of P.J. Lynch, the president of the local improvement association. The march ended a quarter of a mile away at a refreshment tent, where ice cream, cold drinks and peanuts were dispensed to the paraders and spectators alike. Three fine open-air "Punch and Judy" shows were given by Frank Prior in the late afternoon and a fireworks display in the evening completed the liveliest yet the sanest and safest "Fourth" the district has ever experienced. During the afternoon Mayor Fitzgerald visited the scene of festivities. The Mayor, who was given a rousing reception, made a brief speech, in which he congratulated the residents of the district on the success of their celebration." (Courtesy of the BPL.)

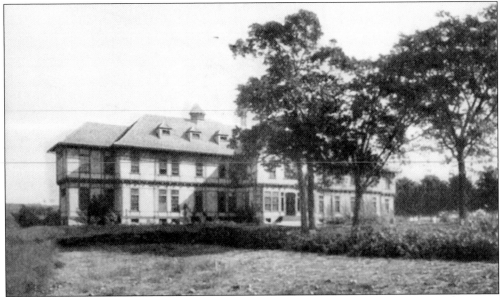

Austin Farm had originally been the female paupers' complex until it was purchased as ward houses for the mentally insane. The Boston Lunatic Hospital had been located in South Boston and was only relocated to Roslindale in 1887. These wards were large structures set on ample grounds in the Mount Hope section of Roslindale. The complex was renamed the Boston Insane Hospital in 1897.

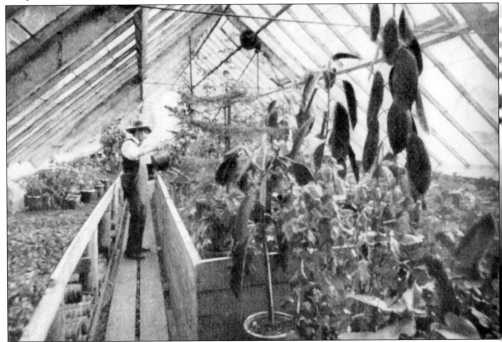

A conservatory was established not only to cultivate bedding plants that were set out to embellish the grounds of Austin Farm, but to provide a distraction for the patients who lived on the farm. It was said that in "the labor department one is as freely trusted with the tools of his trade as if he were a sane man."

Eleven

Austin and Pierce Farms

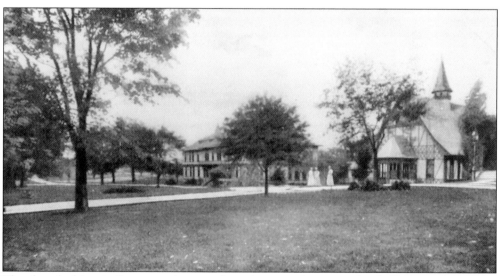

The chapel of Austin Farm, seen here on the right, was a fine example of a Tudor-style building with its long sloping roofs and fanciful cupola. The chapel was also used as the amusement hall of the farm; the central kitchen and bakery were located in the basement. Nurses stand to the left of the chapel in this 1898 photograph.

Two nurses stand on a lawn in front of the superintendent's house, which can be seen in the distance. Dr. Edward B. Lane was the superintendent of Austin Farm at the turn of the century; a graduate of the Harvard Medical School, it was said of him that he "unites the best traditions of the past in the care of the insane with the later results of scientific inquiry."

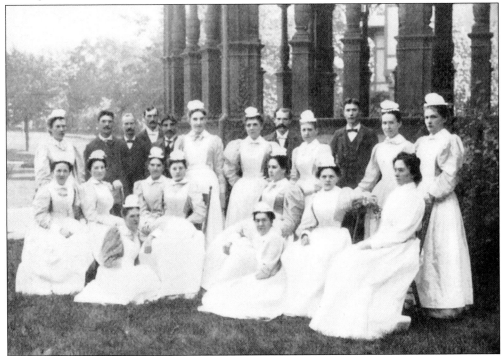

Nurses and attendants at Austin Farm pose for a group photograph at the turn of the century.

Pierce Farm, seen here from Austin Farm, was used to house men confined to the insane hospital. Set in a large tract of open land of 125 acres, Pierce Farm was once owned by the Fottler family who raised produce that they sold at their stall at Quincy Market in Boston. Later, the farm was sold to a man named Pierce, who in turn sold it to the hospital. The grounds were cultivated and had graveled walks, stretches of lawn, flower beds, and numerous shade trees where residents could "take the air."

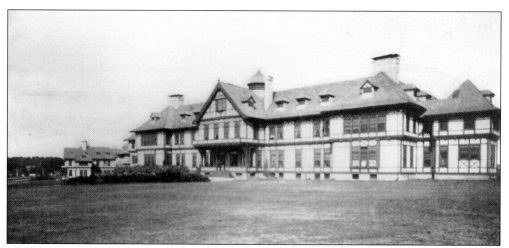

This large dormitory at Pierce Farm had reception, dining, and day rooms on the first floor and rooms for the residents on the second floor.

Acknowledgments

I would like to thank the following for their assistance in researching and, in some cases, for the loan of photographs which have greatly added to the interest of this book on Roslindale, Massachusetts. I sincerely appreciate their continued support and interest: Daniel J. Ahlin, Jeannette Ashe, Anthony Bognanno, Lorna Palumbo Bognanno (President of the West Roxbury-Roslindale Rotary), Paul and Helen Graham Buchanan, Richard Bunbury, Jamie Carter, Michael Cornish and Diane Issa, John Demerjian, Dexter, Carol Dieffenbach, Edward W. Gordon, David Gorin of David's Books, the Hyde Park Historical Society, Nancy Hannan, David and Judith Kunze (who took great efforts to assist me in this book and loaned me a copy of A History of Roslindale, which they wrote and which proved of great assistance), James Z. Kyprianos, Claude Mac Gray, Sarah Markell, Reverend Claudius Nowinski, Terry Pagliuca, Reverend Michael Parise, Dennis Ryan, Anthony and Mary Mitchell Sammarco, Rosemary Sammarco, Kathy Slade, the Roslindale Historical Society, the Roslindale Congregational Church, the Sacred Heart Church, Neil Savage, Sandy Storey, William Varrell, Virginia White, Dorothy Martin (branch librarian), and the staff of the Roslindale Branch of the Boston Public Library.